FATIMAH TUGGAR | HOME'S HORIZONS

This catalogue has an Augmented Reality component that works with your iOS or Android device. Download the app, and follow the instructions on the screen when you see this symbol ⬆ in the catalogue.

To download the *Fatimah Tuggar: Home's Horizons* app, follow this link:

wellesley.edu/davismuseum/tuggar

Powered by BrickSimple LLC

FATIMAH TUGGAR | HOME'S HORIZONS

———— EDITED BY AMANDA GILVIN

HIRMER | the Davis.
DAVIS MUSEUM AT WELLESLEY COLLEGE

HIRMER

Fatimah Tuggar: Home's Horizons

Davis Museum
Wellesley College
106 Central Street
Wellesley, Massachusetts 02481
www.davismuseum.wellesley.edu

The Andy Warhol Foundation for the Visual Arts

Published in conjunction with the exhibition
Fatimah Tuggar: Home's Horizons
Davis Museum at Wellesley College
September 13–December 15, 2019

Curated by Amanda Gilvin, Sonja Novak
Koerner '51 Senior Curator of Collections
and Assistant Director of Curatorial Affairs,
the exhibition and catalogue were realized
with generous support from:

The Andy Warhol Foundation for
the Visual Arts

BrickSimple LLC

Wellesley College Friends of Art at the Davis

Kathryn Wasserman Davis '28 Fund for
World Cultures and Leadership

Mildred Cooper Glimcher '61 Endowed Fund

E. Franklin Robbins Art Museum Fund

Davis Museum and Cultural Center
Endowed Fund

Anonymous '70 Endowed Davis
Museum Program Fund

Judith Blough Wentz '57
Museum Programs Fund

Constance Rhind Robey '81 Fund
for Museum Exhibitions

Designed by Stoltze Design, Boston, MA

Lithography and pre-press
by Reproline Mediateam, Unterföhring

Printed by Printer Trento
Printed in Italy

Edited by Amanda Gilvin

ISBN 978-3-7774-3316-5

Hirmer Verlag Gmbh
Nymphenburger Str. 84
80636 Munich, Germany
www.hirmerpublishers.com

CONTENTS

——————LISA FISCHMAN
RUTH GORDON SHAPIRO '37 DIRECTOR, DAVIS MUSEUM AT WELLESLEY COLLEGE

DIRECTOR'S FOREWORD

It is my great pleasure to introduce *Fatimah Tuggar: Home's Horizons*, the artist's first monograph, published to accompany her major exhibition at the Davis Museum. Encompassing works from 1995 to 2019, the project highlights the artist's oeuvre across media—uniquely positioned at the intersection of traditional craft and new technologies—and the innovative conceptual hybridity for which she is known. Long overdue, this volume contributes new critical scholarship on Tuggar's work and brings incisive contextual analysis to the artist's exceptional practice.
——————It is my privilege to acknowledge all who made this endeavor possible. Firstly, enormous thanks to Fatimah, who is a force of nature, for her brilliant work, and for her tireless and closely collaborative commitment to the project over the many years of its germination. Hearty congratulations to curator Amanda Gilvin on an exhibition finely realized and a beautiful catalogue to ensure its global reach. Amanda imagined this project in the most impactful terms possible, not only creating an in-depth opportunity to engage with Fatimah's work, and commissioning a piece at the edge of new technologies, but also considering the artist's presence as a resource for students, staff, and faculty at Wellesley College. Amanda's passion for Fatimah's work is matched by her commitment to the academic museum context, and to innovating an expanded curatorial

practice. Indeed, The Andy Warhol Foundation for the Visual Arts recognized these qualities through two awards, and provided crucial support for research, development, and programming—for which we are grateful.

——————Many thanks to the contributing authors—Delinda Collier, Associate Professor of Art History, Theory, and Criticism at the School of the Art Institute of Chicago, Nicole Fleetwood, Associate Professor of American Studies and Art History at Rutgers University, and Jennifer Bajorek, Associate Professor of Comparative Literature at Hampshire College—for their essays which consider Tuggar's oeuvre within confluent trajectories of conceptual art, new media, feminist theory, African art, and contemporary practice.

——————Great thanks to the team at Stoltze Design, our award-winning partners in publication, particularly Clif Stoltze, Mary Ross, and Katherine Hughes, for this gorgeous catalogue. A note of appreciation to our colleagues at Hirmer Verlag, particularly to Elisabeth Rochau-Shalem, Senior Editor, Rainer Arnold, Manager Assistant, and Hannes Halder, Producer.

——————Thanks to BrickSimple LLC for their support of the innovative augmented reality (AR) features both in Tuggar's new installation *Deep Blue Wells*, a Davis commission for presentation within the exhibition, and as an extension of this catalogue.

——————It is also my privilege to acknowledge the many donors who supported *Fatimah Tuggar: Home's Horizons* through grants, gifts, and endowed funds.

——————Major funding for the exhibition's development and realization was provided by The Andy Warhol Foundation for the Visual Arts, with additional support from BrickSimple LLC.

——————The Davis benefits from the long tradition of legacy giving at Wellesley College; I extend enormous gratitude to:

Wellesley College Friends of Art at the Davis
The Kathryn Wasserman Davis '28 Fund for World Cultures and Leadership

8

The Mildred Cooper Glimcher '61 Endowed Fund
The E. Franklin Robbins Art Museum Fund
The Davis Museum and Cultural Center Endowed Fund
The Anonymous '70 Endowed Davis Museum Program Fund
The Judith Blough Wentz '57 Museum Programs Fund
The Constance Rhind Robey '81 Fund for Museum Exhibitions

—————— Every member of the Davis Museum staff supports the success of our exhibitions and programs. In this instance, I would like to acknowledge the exceptional contributions of the following to this project: Mark Beeman, Manager of Exhibitions and Collections Preparation; Sarina Khan-Reddy, Media Specialist; Helen Connor, Assistant Registrar for Exhibitions and Digital Resources; and Arthurina Fears, Manager of Museum Education and Programs.

—————— In addition, thanks to Bryan Beckwith, Security Supervisor; Alicia LaTores, Friends of Art Curatorial Research Assistant; Karen McAdams, Friends of Art Coordinator; Bo Mompho, Collections Manager and Head Registrar; Steve Perkins, Security Manager; Craig Uram, Assistant Preparator/Collections Care Specialist; Alyssa Wolfe, Executive Assistant to the Director; Joseph Zucca, Security Supervisor; and to Mary Agnew and Kristen Levesque for media and publicity services.

—————— Finally, enduring thanks to Dr. Paula Johnson, President of Wellesley College, and to Andy Shennan, Dean and Provost of the College, for their enthusiastic and unwavering support of the Davis Museum.

9

—————AMANDA GILVIN

FATIMAH TUGGAR: AT HOME IN THE WORLD

Concrete courtyards, automated kitchens, mud-walled rooms, spaceships: homes of all kinds appear in the artwork that Fatimah Tuggar has produced since the mid-1990s. In one half of her new diptych *Home's Horizons* (2019), a small round adobe home with a thatched roof sits on a radiant blue sea, and underneath, upside down, and underwater, hovers a two-story house with a two-car garage. White pickets mirror woven fencing to stretch across the horizon. What vistas can we see from this hand-built house—and its murky reflection? In the second image, a hand-hewn boat floats over a spacecraft, its parachutes connecting the two vessels. Who has returned from where? What journeys lie ahead?

—————Tuggar's multimedia art practice—which spans performance, sculpture, photomontage, video, virtual reality (VR) and augmented reality (AR)—illuminates how humanity has employed technology to reshape our homes (including our shared planetary home) during the twentieth and twenty-first centuries. The artist, who layers binary code with handmade craft, is one of the most original, incisive conceptual artists of the digital age. Tuggar's artworks, produced over decades of rapid technological innovation, challenge romanticized notions of both ancient traditions and recent inventions. Tuggar approaches technology as both a subject of analysis and a metaphor for power structures.[1] She seeks

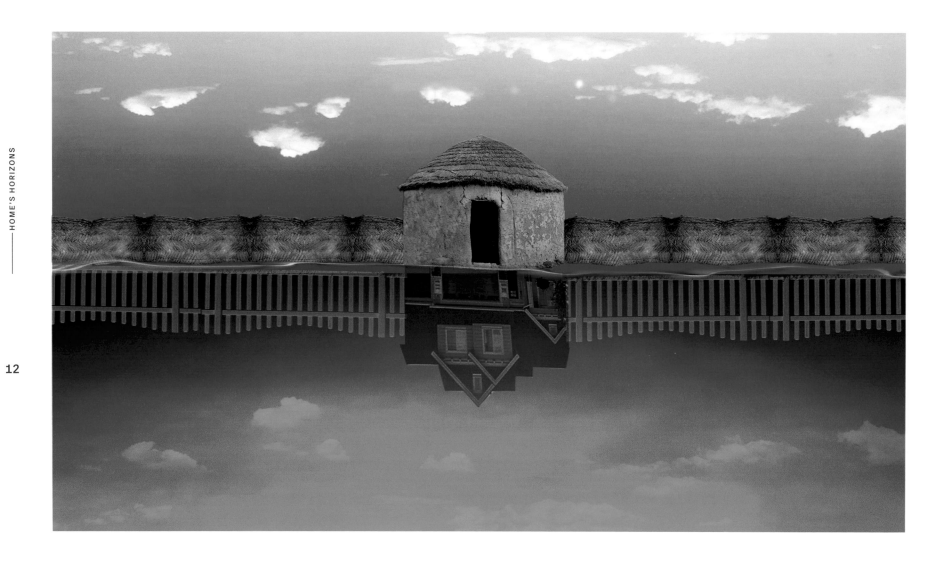

Home's Horizons, 2019
Computer montage (inkjet on vinyl) diptych
40 × 23 in., 40 × 23 in. (101.6 × 58.4 cm, 101.6 × 58.4 cm)

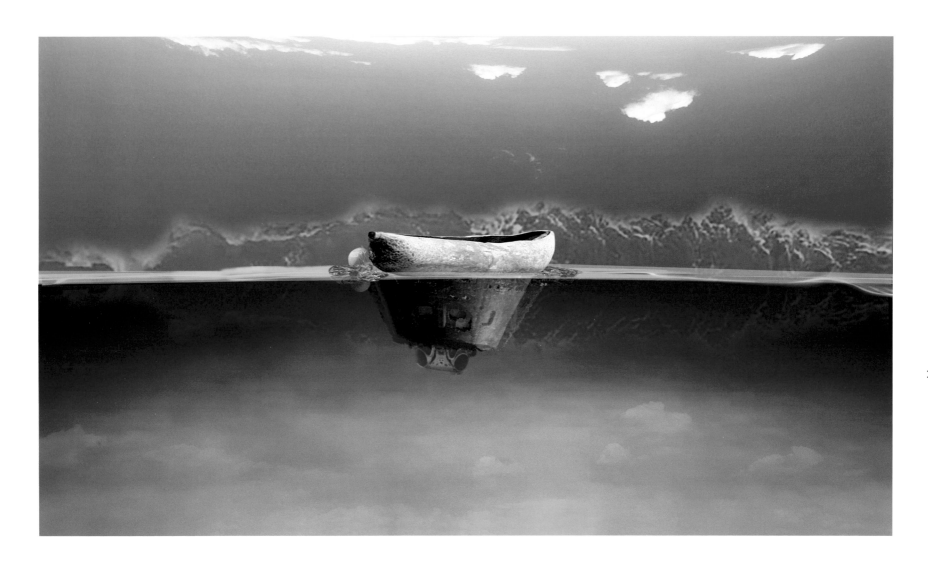

to promote social justice by implicating everyone in imbalanced systems of power, while proposing new ways of seeing and making. Organized into sections that mirror the exhibition layout, this essay will analyze the tension in Tuggar's work between being at home and looking out into the world.

——— The artist has made her own homes on multiple continents. Born in Kaduna, Nigeria in 1967, Tuggar grew up in Kano, and frequently traveled internationally with her family. After attending the Blackheath School of Art in London for secondary school, she moved to the United States for her undergraduate studies at the Kansas City Art Institute. She has continued to move in order to pursue her artistic career, with stints in New Haven, Connecticut; New York, New York; Durham, North Carolina; Toronto, Canada; and a recent return to Kansas City, Missouri. She has exhibited internationally since the 1990s, and she has spoken and exhibited in many countries in Africa, Europe, North America, and Asia. In forging this peripatetic career, she has embraced mobility, explaining that "the world is my studio."[2]

——— As she enters, departs, compresses, and combines homes, Tuggar unpacks the meanings of "technology" in different places and at different times. She has stated that "A computer and a hammer are the same kind of thing. They are both tools."[3] In her 1997 photomontage *Working Woman*, the computer, telephone, lamp, and power strip represent technology, but so too does the handmade screen creating walls around the smiling subject. While the definition of technology in casual parlance generally refers only to "digital software and hardware," Tuggar reflects upon a longer history. Derived from both Latin and Greek roots, "technology" entered the English language in the seventeenth century, then meaning "a discourse or treatise on an art or arts."[4] Only in the eighteenth and nineteenth centuries did it come to emphasize industrial machinery and invention. The term "tech" has evolved alongside the rapidly changing digital inventions of the twentieth and twenty-first centuries to refer above all to the new, the digital, to ever-shrinking objects and ever-expanding networks.[5] Since the mid-1990s,

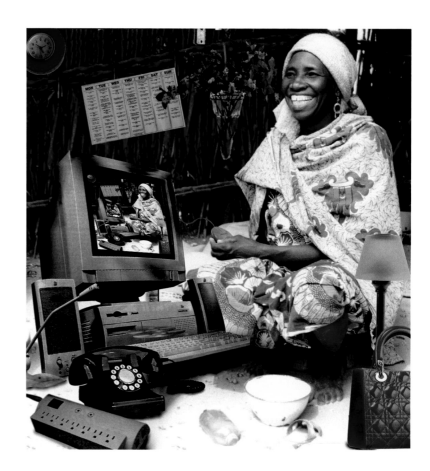

Working Woman, 1997
Computer montage (inkjet on vinyl)
50 × 48 in. (128 × 121 cm)

when many were heralding a coming techno-utopia, Tuggar has insisted that technology encompasses anything that people make or use. Her early work, part of a burgeoning movement in new media arts at the turn of the twenty-first century, contributed to urgent debates about technological access.[6]

——— Discourses around Afrofuturism also began to take shape around this time, and had a great impact on the reception of Tuggar's work. In 1994, cultural critic Mark Dery coined the description to mean "African-American signification that appropriates images of technology and a prosthetically enhanced future."[7] In 2002, sociologist Alondra Nelson included images by Tuggar in a special issue of *Social Text* on the topic.[8] However, while Tuggar's work takes up some of the same issues as Afrofuturism, she has distanced herself from the label:

> While Afrofuturism and science fiction are interested in fantasy projections into the past and future, I am anchored by what I call an "alternative imaginary." I focus on the resources currently available in the world and then imagine through both my medium and my process how I can suggest another possibility. There is no Afrocentrism of all Africans being royalty in my practice, as I am not a fan of monarchy, and certainly where there is monarchy there will be subjects...As far as wanting to be from another planet, I consider myself a stakeholder on this planet and no one can make me leave. We need to stand our ground and continue to work towards change and justice. I will not concede science and technology to only those of European descent and focus on spirits, mysticism, and magic because that is what is expected of my blackness...I come from a Western African community that used systems of logic and fractal mathematics before fractals were considered useful in the West.[9]

——— How does this "alternative imaginary" manifest in Tuggar's work? Her images engage with the past and future, but they are also insistently about our

15

16

ABOVE
Detail, *Home's Horizons*, 2019
Computer montage (inkjet on vinyl) diptych
40 × 23 in., 40 × 23 in.
(101.6 × 58.4 cm, 101.6 × 58.4 cm)

RIGHT
The Spinner and the Spindle, 1995
Computer montage (inkjet on vinyl)
20 × 30 in. (50 × 76 cm)

OPPOSITE
Hannah Höch, *"Trauer" (Aus einem
Ethnographischen Museum)*
[*Sorrow (From an Ethnographic Museum)*], 1925
Collage
6⅞ × 4½ in. (17.6 × 11.5 cm)
Inv. NG 27/79
© 2019 Artists Rights Society (ARS),
New York/VG Bild-Kunst, Bonn
Photo credit: bpk Bildagentur/
Jörg P. Anders/Art Resource, NY

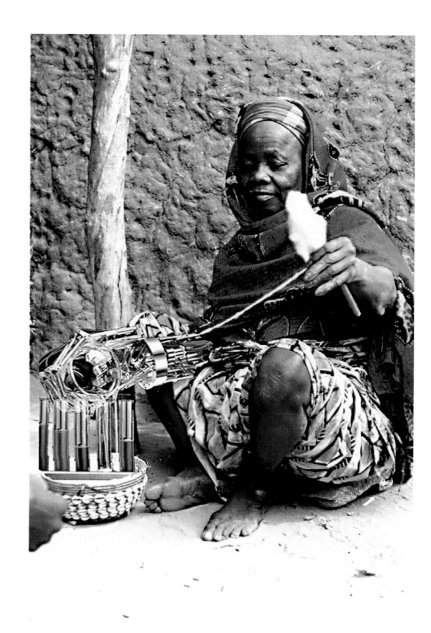

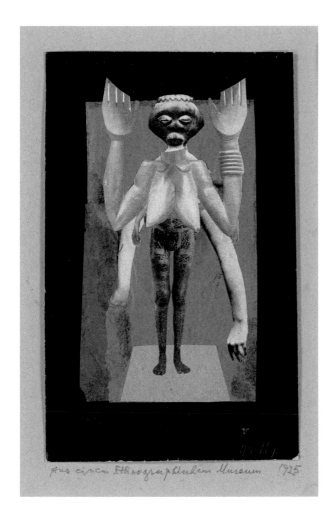

present. A recurrent symbol for Tuggar, the woven fence attests to Africans' long history of using fractal mathematics: the stalk pieces become progressively shorter from bottom to top in response to the stronger wind speed higher from the ground.[10] These fences use fractal mathematics for both aesthetic and structural purposes. With such allusions, Tuggar refuses the suggestion that Africans may only ever "appropriate" technology. Both *Home's Horizons* and *Working Woman* offer an alternative imaginary with wide acknowledgment of the connections between African artisanal expertise and digital innovation.

The Pleasures of Work

Tuggar has described one goal of her photomontages from the mid- and late 1990s as "repositioning the black female through a process of re- and defamiliarization as an active self-agent."[11] This strategy dialogued with the work of artists such as Adrian Piper, Carrie Mae Weems, and Lorna Simpson, but by eschewing self-portraiture, focusing on subjects in Northern Nigeria, and drawing on traditions of bricolage and collage, Tuggar's first photomontages emphasized themes of labor and power over identity.[12] In *The Spinner and the Spindle* (1995), a woman sits in her courtyard spinning cotton. Yet, her robotic right arm does not hold a bobbin of thread, but grasps test tubes resting in a basket decorated with cowrie shells. The robotic and the artisanal become commensurate under this woman's calm concentration.[13]

———— Tuggar's photomontages reference both West African practices of bricolage and European modernist artistic movements, but her treatment of the human form reflects a unique sensitivity to people's diverse lived experiences. For example, in Hannah Höch's *Sorrow (From an Ethnographic Museum)* (1925), the juxtaposition of parts of white women's bodies with African and other "ethnographic" sculpture emphasized the supposedly strange and foreign enigma of non-European people and their arts.[14] In contrast, Tuggar avoids visually mutilating human bodies, because "both the black and female body

has suffered enough trauma throughout history—there is no need to add to that."[15] She also rejects the Modernist canon of African art, which consists primarily of wooden masks and other sculptures, by embracing the artistic media of Northern Nigerian women, including textiles and basketry. The uncanny in Tuggar is not foreign, but rather can draw viewers into a kind of familiarity, creating a sense, perhaps, of home.

———— Tuggar cites German photomontagist John Heartfield as a favorite influence, describing his work as "witty, politically direct, and audacious."[16] In response to Nazi leader Hermann Göring's 1935 claim that mining ore for weapons was superior to the production of butter and lard, Heartfield turned to the home for, as Tuggar puts it, "a microcosm of society."[17] In *Hurrah, the Butter is all gone!,*" a family tucks into a dinner of metal tools and scrap. Tuggar has observed that while her works are not as didactic as Heartfield's, they are no less urgent and political.[18] In *Shaking Buildings* (1996), a high-rise building wobbles in a young girl's sieve. The image's sharp irony hinges on the far greater economic value placed on office work than on cooking, and the reversed power dynamic invites us to reassess housework's value.

Domestic Dreams

To expose the fantastical paradoxes of home-making, Tuggar chooses collage to craft her alternative imaginary.[19] Her media foster a particular relationship between the artist and her viewers: "The collage processes I use bring me closer to the viewer, as they too have to follow the path I have renegotiated with the artwork in order to understand the fragments I have brought together."[20] Tuggar expects her photomontages to challenge our confidence in photographs, but also our faith in *everything* that we see. In *Lady and the Maid* (2000), both women wear expressions of surprise, as Tuggar plays with racial and class codes to question who is working for whom. A white woman in an apron spills a calabash of yogurt. Seated in a large armchair, a black woman eats as she gazes ahead.

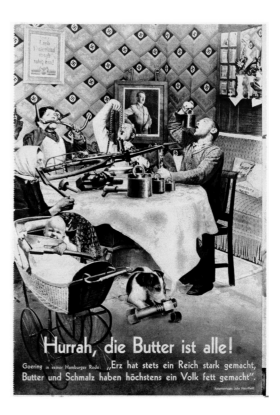

John Heartfield, *"Hurrah, die Butter is alle!"*
(Hurrah, the Butter is all gone!), 1935
Photomontage published in Arbeiter-
Illustrierte-Zeitung, Prague
© The Heartfield Community of Heirs/
Artists Rights Society (ARS), New York/
VG Bild-Kunst, Bonn 2019
Photo: bpk Bildagentur/Art Resource, NY

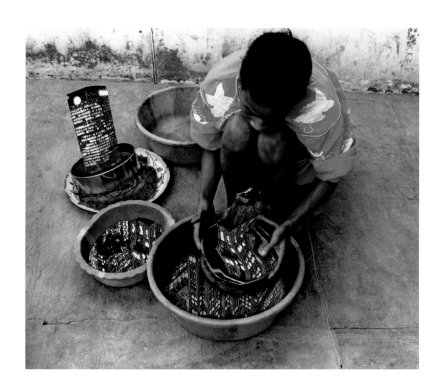

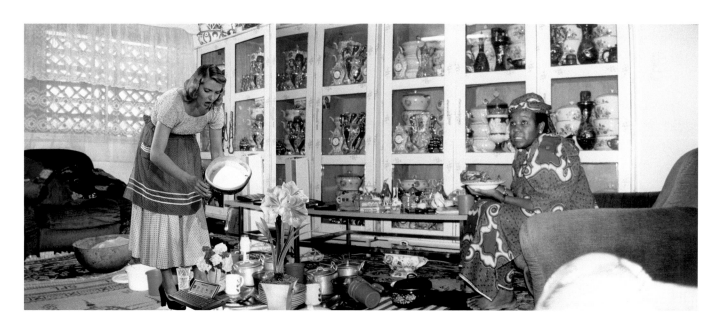

ABOVE
Shaking Buildings, 1996
Computer montage (inkjet on vinyl)
20 × 23 in. (50 x 58 cm)

RIGHT
Lady and the Maid, 2000
Computer montage (inkjet on vinyl)
108 × 45 in. (274 × 115 cm)

One an ideal of mid-twentieth century American advertising and the other a contemporary photograph of a Nigerian, these women inhabit the same space—but they come from different times and places.[21] Nostalgia for the blond woman's 1950s televised world masks the racist segregation and violence that characterized American society of the time, when domestic work was one of the few employment options open to many black women. The deliberate ambiguity demands a reckoning with the past—and how it shapes the present moments that we live and imagine. Informed by semiotic theory and cultural theory, especially theorist Stuart Hall's writings, Tuggar here points to race as a discourse, a social invention.[22] This white woman is not real, but then again, whiteness itself—which novelist James Baldwin once described as an "anxiety fantasy"—is not real.[23]

20

————— One of Tuggar's best known artworks, *Fai-Fain Gramophone* (2010) also collages times and places in a meditation on women's art and creativity. A re-make of the 1996 sculpture *Turntable* (lost in transit from Brussels in 2002), this sculpture acts as an homage to Nigerian musician Barmani Choge (1945–2013), and the work that women do in their homes.[24] Bringing together handmade, electronic, and digital media, the sculpture asserts these technological approaches as coeval, despite fallacies of progress in which the new entirely replaces the old. Made with care by a woman, a *fai-fai* can be a lid, a trivet, a sieve, and even a girdle. It is a multi-tool made by a woman for other women. Vinyl records were named after these once ubiquitous raffia woven disks because of the formal similarity, and Tuggar revels in this word-shape play to call attention to the artistry of fai-fai weavers and one of her artistic heroes. Music by Choge plays on a hidden .mp3 player, as the fai-fai "record" spins. Choge sang with women for women, and together, from their imaginations, they made art, families, and homes.

At the Party

The home is a place of labor, leisure, and celebrations. Tuggar notes that her depictions of parties still "speak to the labor that has preceded, continues during,

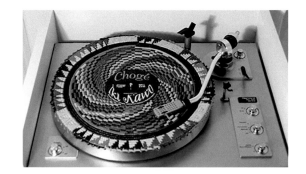

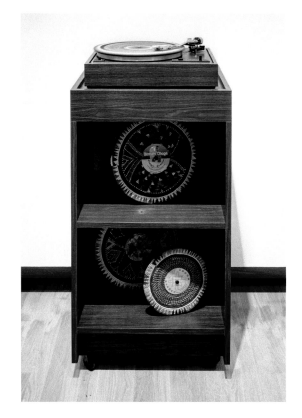

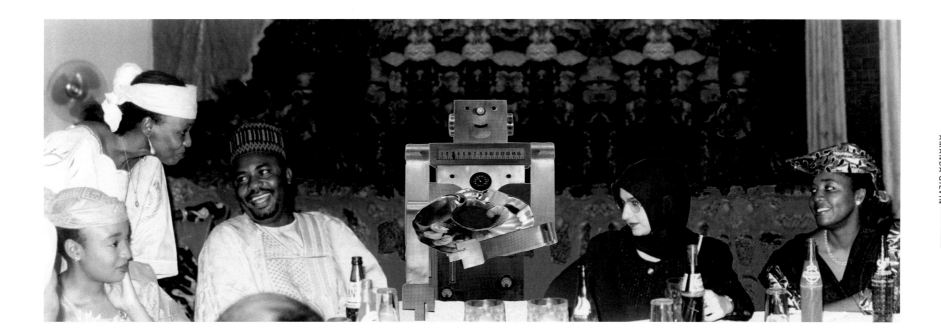

21

OPPOSITE, TOP
Detail, *Turntable*, 1996
Record player, raffia disks, speakers,
labels, Walkman with music by
Barmani Choge
48 × 32½ × 24 in. (121.8 × 82.6 × 61 cm)

OPPOSITE, BOTTOM
Fai-Fain Gramophone, 2010
Record player, raffia disks, speakers,
labels, MP3 player with music by
Barmani Choge
53 × 32½ × 24 in. (134.6 × 82.5 × 70 cm)
Davis Museum at Wellesley College,
Wellesley, MA
Museum purchase, The Dorothy
Johnston Towne (Class of 1923) Fund
2019.944

ABOVE
Robo Entertains, 2001
Computer montage (inkjet on vinyl)
48 × 140 in. (121 × 357 cm)

and will follow the festivities."[25] In *Robo Entertains* (2001), a group sits around in stylish late twentieth-century Nigerian clothes, their faces directed toward the center of the image. The host Robo cradles what is left of a shrimp cocktail platter. He recalls various utopian fantasies of robot servants current in mid-twentieth century American pop culture, and also responds to artist Nam June Paik's (1932–2006) explorations of human relationships to robots.[26] Paik's 1964 *Robo-K-456*, created with engineer Shuya Abe, would sometimes perform on his behalf, and in 1985, he introduced *Family of Robot*, a series of anthropomorphized sculptures that considered how evolving technologies were changing the humans using them. Robo hosts a Nigerian party, but who is he serving? Although uneven access to technologies can perpetuate economic inequality, the purchase of new products generates immense profits for companies committed to planned obsolescence. This old fantasy of Robo foreshadows today's "home assistants," like Google Home and Amazon Alexa, which many find useful—but that may also be surveilling people in their homes in ways they do not understand.

————Made during a residency at The Kitchen, the non-profit arts organization in New York City, the video *Fusion Cuisine* (2000) combines commercial videos from the mid-twentieth century United States and film footage taken by Tuggar in Northern Nigeria in the late twentieth century.[27] The project plays on her host organization's name, and alludes to important feminist precedents like Martha Rosler's *Semiotics of the Kitchen*.[28] Tuggar contrasts the arduous, expert work of Nigerian cooks with advertisements for automatization, which expressed the American ideal of "individual choice" and the desire to free (white) women for lives of leisure. Late twentieth-century Nigerian parties are presented on the video screen of a 1950s American home. As Nicole R. Fleetwood has argued, *Fusion Cuisine* exemplifies how Tuggar exploits the "visible seams" in collage by emphasizing moments of incongruity so as to assert the presence of black women as viewers, users, and creators of technology.[29] As the video compresses time and space, it investigates racialized ideas about womanhood, domesticity, and technology. Surely, we can see a critique of a lack of access to electricity for many Nigerians, but the white woman dancing in her pristine kitchen also seems sad in comparison to the large celebrations for which she can only be a voyeur. As we stare at a screen to watch the video, this artwork humorously cautions against the tempting hubris in judging the hopeful consumerist pitches of yesteryear. Our perceptions of the past and of different places are necessarily mediated—and what screens are we looking at and through to see other people?

People Watching

In *People Watching* (1997), which Tuggar made for exhibition at the second Johannesburg Biennale, she expands her analyses of homes—and what is seen from them. An Ndebele woman in triplicate acts as a surrogate watcher, taking in the strange scene from the bottom right corner.[30] In the common tourist materials that Tuggar used as source material for this and other related works,

Still from *Fusion Cuisine*, 2000
Video collage, 15 minutes, 40 seconds
Technician: James Rattazzi
Intern: San Woo
Participants: Aishatu Usman, Amina Mohammed Duku, Bintan Kwakwata, Halima Usman, Hawa Abdullahi, Yalwati Anyama, Villages of Tilde and Ɗukul
Found footage from the Ephemeral Film Archives
Produced by The Kitchen and BintaZarah Studios

22

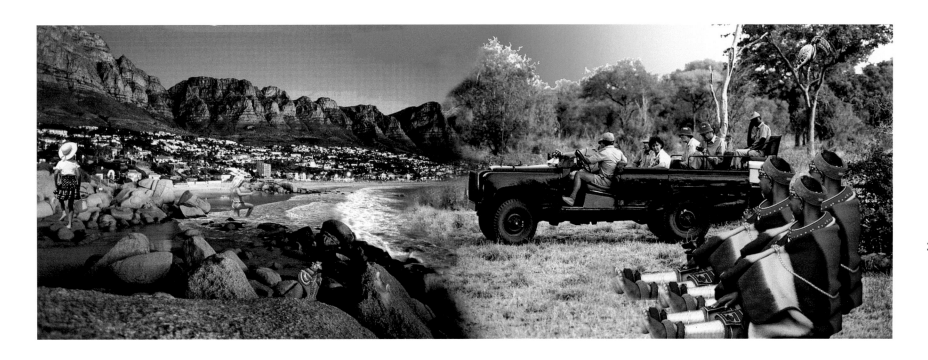

People Watching, 1997
Computer montage (inkjet on vinyl)
34 × 96 in. (86 × 243 cm)

the post-Apartheid state continued to treat Ndebele women—whose beautifully painted houses had been popular destinations for white South Africans and foreign visitors for decades—as objects of the tourist gaze. Pointedly, the single woman in a crowded open-air truck looks at the Ndebele women, suggesting close similarity between white tourists' safaris to view animals and their expeditions to see "exotic" people. *People Watching* begs the question: who is watching whom? The flattened dimensions challenge perspectival conventions, evoking Romare Bearden's subtle backgrounds in his prints based on collages. The effect conveys the ease of air travel promised by tourist brochures, just as Bearden abstracted space in his meditations on rail travel. In *The Train*, large faces gaze out from the center, and the title's locomotive takes only a small piece of the upper left corner—despite its great impact as a symbol for people on the move and for those left behind. Likewise, in Tuggar's digital photomontage, collage accentuates the act of looking, and thwarts attempts to distinguish background and foreground. As people stare at one another under a bisected horizon, we are left with still more unsettling questions: in a post-apartheid South Africa, a rainbow nation inventing itself out of a segregated settler colony, who is at home?

Deep Blue Wells

Tuggar has observed that many Nigerian arts and crafts are at risk of disappearing as the current generation of artisans retires. Inverting long-held mythologies, she insists that only through using older technologies can we improve new ones. Her new commission for the Davis Museum, *Deep Blue Wells*, pushes at the limits of current digital technologies while honoring expert artisanal work. She filmed for the installation in Kano, Nigeria, and the title refers to the indigo dye wells of that city. Walking into *Deep Blue Wells*, the visitor first encounters ceramic sculptures on the floor, which emulate the earthen walls once constructed around Kano's wells. Hidden projectors

ABOVE
Romare Bearden, *The Train*, 1974
Color aquatint, etching and photo engraving,
with handcoloring in watercolor, hand colored proof,
aside from the edition of 125
Sheet: 22⅛ × 30⅜ in. (56.2 cm x 77.2 cm)
Image: 22⅛ × 30⅜ in. (56.2 cm x 77.2 cm)
Davis Museum at Wellesley College, Wellesley, MA
Museum purchase, The Nancy Gray Sherrill,
Class of 1954, Collection Acquisition Fund 2010.91
© 2019 Romare Bearden Foundation/Licensed by
VAGA at Artists Rights Society (ARS), NY

OPPOSITE, TOP
Preparatory model for *Deep Blue Wells*, 2018

OPPOSITE, BOTTOM
Gate to Kano tie-dye pits, still from AR content in
Deep Blue Wells, 2019

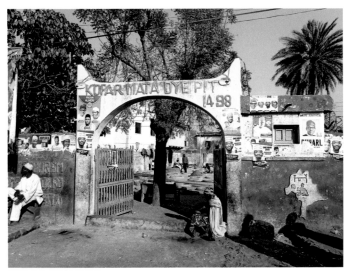

create scenes of blue liquid in movement—as if one could stare down into these wells. Hand-dyed indigo textiles from Kano hang on the walls, while patterns on them can be scanned by mobile phones and tablets to access the AR content.

——— AR facilitates a new kind of collage through layering virtual images over the "real." Furthermore, even the "real" is mediated through a digital device, again calling into question the indexicality of the reproduced image. By embedding part of the artwork in an application available on mobile devices, Tuggar also calls visitors' attention to their phones and tablets as objects with complex histories and often unpredictable impacts, extending her characteristic meditation on technology to the very devices on which part of the work is displayed. Through AR, Tuggar seeks to shift viewers' perspectives, teasing the human desire to see and experience dimensions, places, and time periods that we cannot access physically. Accessed by scanning a textile named after the seven founding states of the Hausa Kingdom, animated shorts portray parts of the historical epic. Another cloth activates an animation of an indigo molecule taking shape. Other videos introduce dyers and other people involved in the production and trade of the textiles dyed in Kano.

——— *Deep Blue Wells* is part of Tuggar's larger project *Creative Reactions*, which she describes as "a series of interactive multimedia artworks that explore disappearing or neglected old West Africa crafts as sources for innovation and imagination." It differs from recuperative projects led by both businesses and non-profit organizations in approaching West African crafts as arts with significance equal to her own contemporary multimedia practice. She has again chosen media often not included in the formal study of West African arts: textiles, woven raffia disks, and calabash decoration. With its incorporation of digital media and its focus on Hausa-Fulani dyeing traditions, *Deep Blue Wells* creates a strikingly unique—and uniquely interactive—portrait of a specific artistic practice and its history.[31]

25

————*Deep Blue Wells* expands the ways that we access history: we can find political dynasties in textile motifs, economic analyses in AR videos, and art histories in glowing sculptures. In 2019, Kano remains an important commercial center, but like other communities in northern Nigeria, northern Cameroon, and Niger, its residents face rising dangers from Boko Haram and political violence. In her newest alternative imaginary, Tuggar emphasizes the creativity and beauty in the work of this historic city.

————An encounter with Tuggar's work causes us to view our worlds differently. Who is at home under a thatched roof—or behind a picket fence? Whose work matters? Who is the lady and who is the maid? What does technology give us? How do we see one another? Who is watching whom—and what power does that give them? What is the role of artisanal knowledge in a digitized world? Rather than answering the difficult questions that she raises, Tuggar provides a conceptual orientation that can prepare us to respond for ourselves. What horizons can you see from your own home?

26

ABOVE
Detail, Indigo fabric with Parliament
House design, from installation
content in *Deep Blue Wells*, 2019

OPPOSITE, TOP
Sketch for 3-D animation of indigo
molecule, still from AR content in
Deep Blue Wells, 2019

OPPOSITE, BOTTOM
Sarkin Karofi Alhaji Audu Uba
working at a dye pit, still from AR
content in *Deep Blue Wells*, 2019

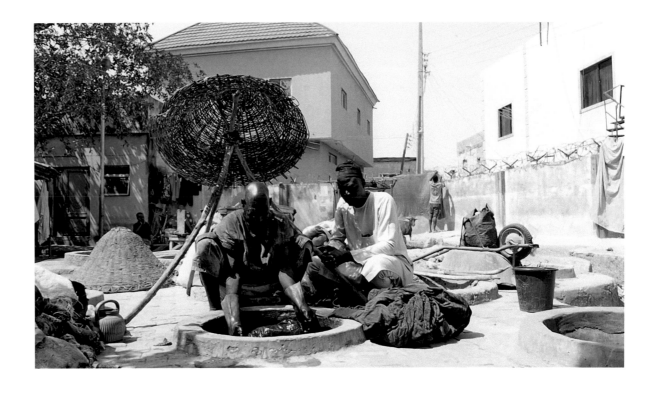

1. Fatimah Tuggar, "Methods, Making, and West African Influences in the Work of Fatimah Tuggar," *African Arts* 50, no. 4 (2017): 13–14. Fatimah Tuggar, "Montage as Tool of Political Visual Realignment," *Visual Communication* 12, no. 3 (2013): 375. Many other scholars have addressed Tuggar's treatment of technology. See also Silvie Fortin, "Digital Trafficking: Fatimah Tuggar's Imag(in)ing of Contemporary Africa," *Art Papers* 29, no. 2 (March/April 2005): 24–29; Yates McKee, "The Politics of the Plane: On Fatimah Tuggar's Working Woman," *Visual Anthropology* 19, no. 5 (2006): 417–422.

2. Tuggar, "Methods, Making, and West African Influences," 14.

3. Fatimah Tuggar, phone conversation with the author, October 17, 2016.

4. "Technology," *Oxford English Dictionary* (Oxford: Oxford University Press, 2008), continually updated resource.

5. Theorists have explored many other possible meanings for "technology" including the "means of engineering," "a philosophy," "modes of communication," "a constant becoming and emerging," "a metaphor," "an ideology," or "a process through which inputs are combined into an output." See Malcolm McCullough, *Abstracting Craft: The Practiced Digital Hand* (Cambridge, MA: MIT Press, 1998), 67; Jeanne Randolph, "Influencing Machines: The Relationship Between Art and Technology," in *Psychoanalysis and Synchronized Swimming and Other Writings on Art* (Toronto, ON: YYZ Books, 1991), 38. Thanks to Nicole R. Fleetwood and members of the Fall 2018 Wellesley College Faculty and Staff Seminar on Art, Race, Gender, and Technology for their contributions to this list.

6. See Anna Everett, "The Revolution Will Be Digitized: Afrocentricity and the Digital Public Sphere," *Social Text* 20, no. 2 (2002): 125–146 and Olu Oguibe, "Connectivity and the Fate of the Unconnected," *Social Identities* 5, no. 3 (1999): 239–248 (later re-published in *The Culture Game* in 2004). Although Tuggar's work has implications for anyone using technology in the world, her work has primarily been analyzed within the context of contemporary African art, rather than new media art. See Delinda Collier's essay in this volume and María Fernández, "Postcolonial Media Theory," *Art Journal* 58, no. 3 (Autumn, 1999): 58–73.

7. Mark Dery, "Black to the Future: Interviews with Samuel R. Delany, Greg Tate, and Tricia Rose" in *Flame Wars: The Discourse of Cyberculture* (Durham, NC: Duke University Press, 1994), 180.

8. Alondra Nelson, "Introduction: Future Texts." *Social Text* 20, no. 2 (2002): 12.

9. Tuggar, "Methods, Making, and West African Influences," 12–17.

10. Ron Eglash argues that contemporary understandings of both fractals and binary code have their roots in African systems of knowledge, having arrived in European mathematics via Arab mathematicians who were themselves influenced by African design and divination. Ron Eglash, *African Fractals: Modern Computing and Indigenous Design* (New Brunswick, NJ: Rutgers University Press, 2005), 70–73. Tuggar first encountered Eglash's scholarship around 2008, when she was teaching at Duke University. See also Delinda Collier, "Obsolescing Analog Africa: A Re-Reading of the 'Digital' in Digital Art," *Critical Interventions* 8, no. 3 (2014): 281.

11. Tuggar, "Montage as Tool of Political Visual Realignment," 375.

12. Since Tuggar made her first photomontages, other scholars and artists have continued to excavate and transform artistic and popular imagery of black women. For example, the Davis Museum at Wellesley College hosted the important exhibition, *Black Womanhood: Images, Icons, and Ideologies of the African Body*, which originated at the Hood Museum of Art, from September 17 until December 14, 2008. Barbara Thompson, *Black Womanhood: Images, Icons, and Ideologies of the African Body* (Seattle, WA: University of Washington Press, 2008). See also the more recent *Posing Modernity: The Black Model from Manet and Matisse to Today*, which was exhibited at the Wallach Art Gallery at Columbia University in 2018 and the Musée d'Orsay in 2019. Denise Murrell, *Posing Modernity: The Black Model from Manet and Matisse to Today* (New Haven, CT: Yale University Press, 2018).

13. Collier has described how this work "relativizes labor through the figure of the cyborg." Collier, "Obsolescing Analog Africa," 281. See also Fortin, "Digital Trafficking," 24.

14. Maud Lavin, *Cut with the Kitchen Knife: The Weimar Photomontages of Hannah Höch* (New Haven, CT: Yale University Press, 1994), 140, 173.

15. Fatimah Tuggar, email interview with the author, March 3, 2019.

16. Fatimah Tuggar, email interview with the author, March 3, 2019.

17. In a 1935 speech, Göring proclaimed that "Ore has always made the empire strong, butter and lard have made a country fat at most." Peter Pachnicke and Klaus Honnef, eds., *John Heartfield* (New York, NY: Harry N. Abrams, Inc., 1991), 39. See also Douglas Kahn, *John Heartfield: Art and Mass Media* (New York, NY: Tanam Press, 1985).

18. Kristin Chambers, *Threads of Vision: Toward a New Feminine Poetics* (Cleveland, OH: Cleveland Center for Contemporary Art, 2001), 54.

19. Tuggar, "Montage as Tool of Political Visual Realignment," 375.

20. Tuggar, "Methods, Making, and West African Influences," 13. See also Judith K. Brodsky and Ferris Olin, eds. *The Fertile Crescent: Gender, Art, and Society* (New Brunswick, NJ: Rutgers University Institute for Women and Art, 2012), 160.

21. Gary Sullivan, "Fatimah Tuggar: Interview" http://home.jps.net/~nada/tuggar.htm (Accessed October 6, 2016).

22. David Morley and Kuan-Hsing Chen, eds., *Stuart Hall: Critical Dialogues in Cultural Studies* (London: Routledge, 1997); Jennifer A. González, "The Face and the Public: Race, Secrecy, and Digital Art Practice," in Wendy H. K, Chun, Anna W. Fisher, and Thomas Keenan, eds. *New Media, Old Media: A History and Theory Reader* (New York, NY: Routledge, 2016): 713.

23. Delaney's citation of James Baldwin's description of whiteness as an "anxiety fantasy" is the most relevant take-away from the series of interviews in which Dery introduced the concept of Afrofuturism. Mark Dery, "Black to the Future," 190; James Baldwin, *The Price of the Ticket: Collected Nonfiction: 1948–1985* (New York, NY: St. Martin's, 1985), xiii.

24. Tuggar sometimes includes an accent in Choge's name in order to teach American and European audiences the correct pronunciation, which is "Choh-gey." See also Trevor Schoonmaker, *The Record: Contemporary Art and Vinyl* (Durham, NC: Nasher Museum of Art at Duke University, 2010), 200.

25. Fatimah Tuggar, email interview with the author, March 3, 2019.

26. Fortin, "Digital Trafficking: Fatimah Tuggar's Imag(in)ing of Contemporary Africa," 28–29; Melissa Chiu, et al., *Nam June Paik: Becoming Robot* (New York, NY: Asia Society Museum, 2014).

27. For the earlier source material, Tuggar plumbed two collections of historic advertisements. Rick Prelinger and Robert Stein, *You Can't Get There from Here: Ephemeral Films, 1946–1960* (Los Angeles, CA: Voyager Press, 2000); and Robert Stein and Rick Prelinger, *To New Horizons: Ephemeral Films 1931–1945* (Los Angeles, CA: Voyager Press, 2000).

28. Nancy Spector, "Fatimah Tuggar," *Cream 3: Contemporary Art in Culture: 10 Curators, 100 Contemporary Artists, 10 Source Artists* (London: Phaidon, 2003), 384; Silvie Fortin, "Digital Trafficking: Fatimah Tuggar's Imag(in)ing of Contemporary Africa," 24.

29. Nicole R. Fleetwood, *Troubling Vision: Performance, Visuality, and Blackness* (Chicago, IL: University of Chicago Press, 2011), 193.

30. Chambers, *Threads of Vision: Toward a New Feminine Poetics*, 56.

31. Several other contemporary artists engage with the history of indigo in West Africa as a theme and use it as their medium. Lagos-based Nigerian artist Chief Nike Davies-Okundaye has led a revival of Yoruba indigo dyeing, and her Nike Art Centers now host artists who spin cotton, weave thread, dye textiles, and train others. Nike Davies-Okundaye, *Nike Davies-Okundaye: A Retrospective* (London: GAFRA ART, 2014). See also http://www.nikeart.com/artcenters.htm (Accessed March 25, 2019). Malian-French artist Aboubakar Fofana has been working with communities in Mali for over a decade to make both conceptual artwork and marketable clothing and homegoods. See "Aboubakar Fofana," on https://www.documenta14.de/en/artists/13516/aboubakar-fofana (Accessed March 25, 2019). Fellow Kano native, the Paris-based Native Maqari, was also inspired by the wells in a recent video collaboration with contemporary dancer Qudus Onikeku. Native Maqari, Public Lecture, Omenka Gallery, Saturday, July 14, 2018. See also https://www.omenkaonline.com/native-maqari-leftovers/ (Accessed March 25, 2019).

29

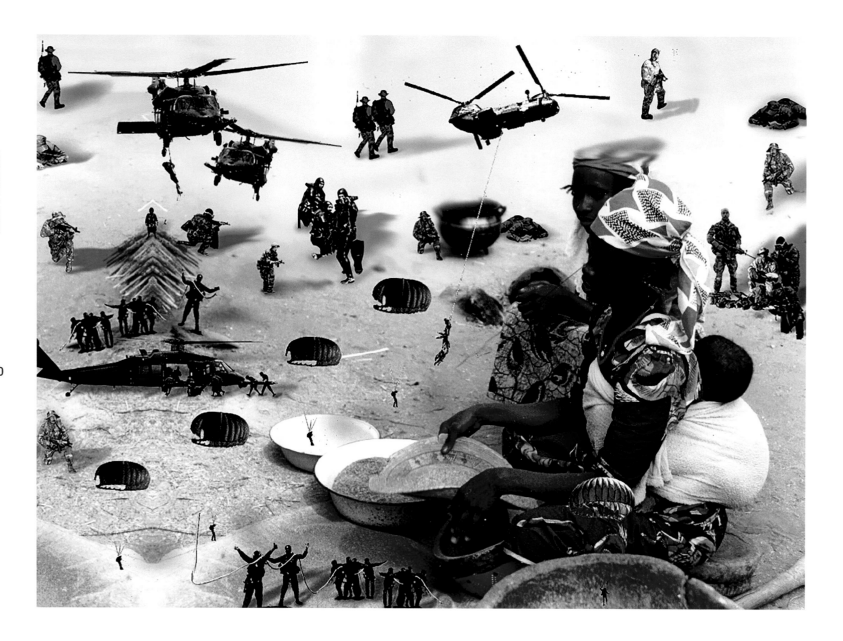

Untitled (Army), 1996
Computer montage (inkjet on vinyl)
36 × 48 in. (91 × 121 cm)

INTERVIEW WITH THE ARTIST

Amanda Gilvin: What does "home" mean to you?

Fatimah Tuggar: As someone who grew up in multiple places and continues to move from place to place, my sense of home has a much broader scope. Home is our planet. Home is where I create a temporary sense of order and control to think, contemplate, produce, and find a moment's peace. I can make a home in any space I inhabit; it is more a state of mind than a physical geographical location. In my personal life, there is no space where my home begins or ends that is not a part of my studio. The world is my studio.

AG: What horizons can you see from a home?

FT: Coming from a historically nomadic people (known as the Fula, Fulɓe or Fulani) lets me hope that the idea of location does not set limits on the potential of my horizons. I aspire to horizons that bring outlooks and perspectives that are not limited or contained by walls or roofs. I want my horizons to encompass social and environmental justice in an orbit that recognizes that equality for others takes nothing away from those with privilege.

AG: Why is the home such an important site for you?

FT: The domestic provides a microcosm of society. I find this approach to be an excellent lens for taking the pulse of what is going on at multiple levels: from the micro to macro and from one location to another across class and race structures. Since I am not interested in technology as a fetish or an end in itself, I am focused on its impact on our lives and how it changes our relationships with society, each other, and ourselves. I target the identifiable contexts of domestic tools and locations, and often even how commercial and industrial interfaces are a focal point within our households, because that is a field in which certain power games are played.

AG: How has music contributed to the development of your artistic practice?

FT: My early childhood in Northern Nigeria provided me with no visual artists as role models, so I turned to music as an example of what was possible. I was looking at Dan Maraya Jos's standing up for the downtrodden, Haruna OJ's engagement of the daily domestic, Yan Matan Gawo's poetic call and response lyrics, Barmani Choge's humorous feminist advocacy, and they all provided models of how to be an artist. I learned that content and accessibility matter, not just form and technique. Then, when my sister Khadijah started going to university, she introduced me to Fela Kuti's local political challenges and Miriam Makeba's anti-apartheid approach. Their music reinforced to me the importance of a mission: thinking and form have to be harmonious with artistic methodologies.

———— In my teens in the UK, I regularly snuck into reggae dancehalls as an under-aged girl, and I listened to DJ David Rodigan on the radio. I learned that reggae is not just driven by tempo, but also by social and political consciousness. This is the lesson of not only Bob Marley and Burning Spear, but also Steel Pulse's clean and tight execution. As always, each type of music and musician came with their own visual sensibility, and this allowed me to understand aesthetics long before my visual arts education. Being in London at the tail end of the punk rock era enabled me to witness how art could be a tool of political subversion under Margaret Thatcher. As with many Western cultural producers, the Clash made an impact on me. Both the Wells Fargo and Johnny Cash are also examples of how courageous art can inspire action. I aspire to that kind of art-making.

———— A part of my awakening to the use of cultural sampling was early rap. The Sugarhill Gang and Public Enemy continue

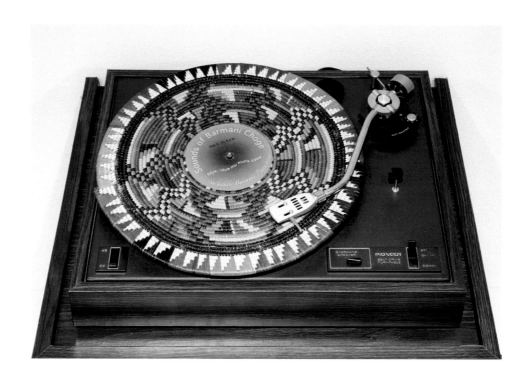

Detail, *Fai-Fain Gramophone*, 2010
Record player, raffia disks,
speakers, labels, MP3 player
with music by Barmani Choge
53 × 32½ × 24 in. (134.6 × 82.5 × 70 cm)
Davis Museum at Wellesley College,
Wellesley, MA
Museum purchase, The Dorothy
Johnston Towne (Class of 1923) Fund
2019.944

to sway me. As music embraces storytelling through lyrics, I learned to tell stories with my work by studying artists like Creedence, Betty Wright, Linda Thompson, Joe Jackson, Anne Feeney, and Elvis Costello. I am still a student of music, retrospectively exploring Umm Kulthum, Nina Simone, Sam Cooke, Marvin Gaye, and an endless list of musicians. I examine musical methodologies and models for how to move my practice forward. For example, Prince further allowed me to understand the importance of being versed in multiple media and approaches, or cinematics and multi-instrumentalism as was the case for him. He was also a model, with Ray Charles, for taking control of one's artistic destiny.

AG: Could you say more about Barmani Choge as a musician and your personal relationship to her and her work? What is the significance of highlighting her music in *Fai-Fain Gramophone*?

FT: I met Barmani Choge (pronounced "choh-gey") during my sister's wedding. Our weddings last a week and usually have live music. Other musicians played at the wedding, but she was the only musician who stayed for the whole week. She shared my bedroom with me, and I had the opportunity to ask her about how she became an artist and about her artistic choices.

———— The use of Choge's music for *Fai-Fain Gramophone* calls attention to the fact that this sort of artist and musician, while very popular in Northern Nigeria, will never have a record nor be globally commodified for several reasons. For example, music without the use of Western instruments rarely makes it to the global market, even in the genre of so-called "world music." I wanted to seize the opportunity to create a visual artwork in these sculptural LP 'records' for an artist who I consider to be a creative master, even if she will never have national or global recognition.

———— The content of the artwork is a play on words. A *fai-fai* or raffia disc is used in place of the vinyl record in the artwork because when record players were introduced into Northern Nigeria, the term for vinyl records became "fai-fain gramophone" due to the visual similarities of vinyl and the raffia disc. So, it was essential to appropriate local music that did not use imported instruments to represent the also appropriated raffia disk or fai-fai.

———— I also think the poetics of Ammada Music is fitting. Ammada is a distinct music genre usually only performed by women using kitchen utensils, and the fai-fai is also a kitchen item. I say "usually" here, because I know that the musical predecessor of Choge, Uwalia Mai Ammada had her husband as one of her musicians, but he was and still is the only male I have ever known to play this type of music.

———— The vocals of Choge were another reason for my choice. Her songs were feminist, with lyrics such as: why women should work, the joy of childbirth, and nighttime is a blessing, because it yields the possibility of rest—unless there is sex.

AG: What has been the impact of Marcel Duchamp's art on your own?

FT: Learning about Duchamp's work was both energizing and liberating. The use of the found object changed everything for art, and I realize I am building on this tradition. The tradition of

33

the readymade favors ideas over the hand of the artist. Then what transforms something into art? If art is about making choices about context and perception, thereby creating content, do only the artists' decisions make this art? This approach calls into question the very definition of art. I always have this questioning approach in the back of my mind as a part of my process.

AG: How does your practice relate to practices of assemblage and modification common in Nigeria?

FT: It is not just in Nigeria that people embrace the act of bricolage. As far as I know, this is all over Western Africa, where there are similar conditions of trying to make do by ingeniously improvising with what is available. We see this in the production of early cinema in the region with processes and terms like mégotage, a term coined by Ousmane Sembene. I found it easy to give myself permission to use found materials and alter objects because of my familiarity with this kind of thinking and mindset. This allows my efforts to be focused on content and execution.

AG: How has your engagement with the theme of labor changed over time?

FT: My interest in labor is tied to equity. My relationship with work has not changed. I still think we live in a world where some people's labor is not recognized or compensated fairly. Issues of gender, race, and class still dominate our relationship to how we reflect on people's contributions to society. I will continue to explore this subject until it changes or I die. I try to highlight the relationship between work and dignity and to address categories of work that are invisible or devalued. For example, *Untitled (Army)* (1996) provides a quick comparative analysis of domestic labor and war labor.

—— War labor is glorified as it is connected with masculinity, heroism, and nationalism, but both kinds are labor for the masses to carry out. Also, there used to be more of a gap between play and work, which is now being bridged since this image was made. We now have war tools, drones for example, with playfully deadly game-like qualities; this is a question I am beginning to engage in works like *Hospitable Hostilities* (2018).

AG: What is the relationship of your own work and labor to the themes of work in your artwork?

FT: I am grateful for the opportunity to live life engaging my life's mission and labor for something I love. Beyond that, my own efforts are no different than anyone else's. The market-driven art-world wants artists to work with little or no remuneration. There isn't the thinking that if you value the work, you support the artist. People tell themselves that they are helping artists because they are giving their work "exposure," so they do not need to compensate them for their labor. As time goes on, you may have exposure, but life gets trickier. Artists have to survive, too. The reason why artistic production may be devalued is the assumption that all artists' labor is intuitive as if we are just engaging our whims, but some artists' practice involves the rigorous engagement of ideas, investigations, and challenges to the status quo. However, no matter what approach we take to art making we all have to negotiate our labor with time, material, and the realities of bodies and minds.

Hospitable Hostilities, 2018
Computer montage (inkjet on vinyl)
84 × 96 in. (213.4 × 243.8 cm)

34

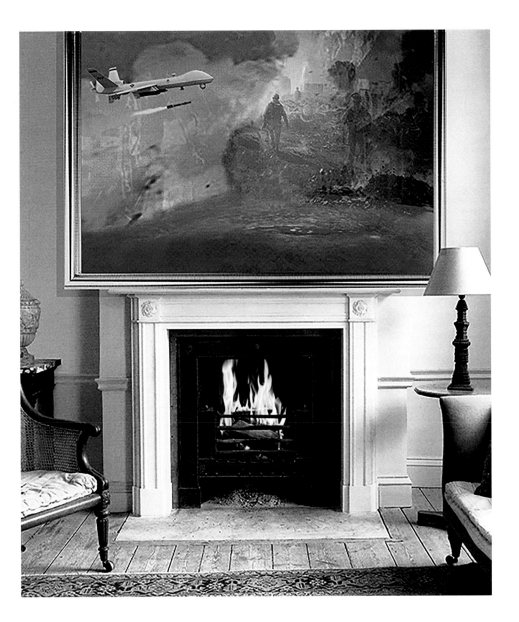

AG: How does the theme of labor relate to your interest in collaboration?

FT: I think that at its core all work is collaborative. Even the actions of making my images or objects for which I am considered the sole producer are cooperative, since I did not make the camera, computer, or the software applications, and I use found sounds, footage, and images. My object-based works are made from what others have made. Not to be tautological, but all of work and life is collaborative. We are all building on other people's knowledge and labor. The question is: How do we acknowledge, respect, and compensate other people's contributions?

AG: What is the importance of labor in the new commission, *Deep Blue Wells*?

FT: *Deep Blue Wells* is an exploration not only into the tie-dye wells in Kano, but also the collaborative labor of the women who design the fabric patterns, both traditional and contemporary, by tying the textiles; and the men who do the dye prep and dying. This is why the artwork spends time engaging and collaborating with the makers. The labor of indigenous craftspeople usually goes unacknowledged. The emphasis is often only in the resulting goods. I see this work as an opportunity to bring the makers to the foreground of the conversation.

——I am also impressed with the resilience of this sort of work throughout history. The process has been passed down for 500 years, and the fabrics continue to have a market not just locally or within the continent, but places as far away as Detroit and London still import these fabrics. This interest

35

shows the longevity and ingenuity of an old idea. Colonialism and modern technology have not obsoleted this approach.

AG: What roles do parties and celebration play in your work?

FT: The compositions speak to the labor that has preceded, continues during, and will follow the festivities. The celebration is not a retreat or respite from labor, but an embrace of productivity as a core of collective human experiences. We must remember that celebrations happen as a result of someone's labor. The hope is to celebrate life in full, including its difficulties. *Girl Talk* (2001) is more about the excess of a celebration than the celebration itself. Both *Girl Talk* and *Cake People* (2001) speak to the influence of Western celebrations with cakes and wedding rings, which have become globally adapted consumer phenomena. *Fusion Cuisine* (2000) shares even more of the intersections between labor and celebration: with cooking, industrial, and traditional household appliances. At the birthday party in the video, even a horse works by giving children rides.

AG: What are some of the power dynamics that you are interested in exploring through technology?

FT: The subject of power dynamics permeates my entire body of work and practice. I see technology as a catalyst for how power is disseminated. So, my work explores how technology mediates power and modifies our experiences. One core subtext is transitional agency and utility: Who has access? What are our interventions? How are we mutated? Where do we connect, abdicate, and disintegrate? I am pursuing the inter-relationships

36

Cake People, 2001
Computer montage (inkjet on vinyl)
48 × 58 in. (121 × 147 cm)

of race, class, and gender to power and technology. Technology is an instrument, but it only rarely has any intrinsic moral values attached to it. I am, of course, aware that individual and cultural values can and are always built into technology. But essentially, it is just a tool like any other. It is not binary in the sense that it is bad or good. It is, however, the cypher of our age. Ultimately, like any tool, what we do with it is what matters.

AG: What technological changes in your life have impacted you most, and how?

FT: From a historical standpoint, I would say that plumbing and the refrigerator, where they are available, have provided the most significant changes to the human condition. Sanitation improves life expectancies and health. Preserving foods has changed how we shop for food and how we prepare our meals. ——————Since I have been lucky enough to have access to refrigeration and sanitation all of my life, I have to personally say, the computer and the internet have had the most impact on my life. I am old enough to remember when we had no computers or internet. Everything was not instantly messaged, libraries had picture files, and artist mailed slides of their works by post. The digital has shifted how I make collages. I do not cut out and paste images on paper. Producing versions and iterations on the computer is quicker and more comfortable. Editing video footage and rotoscoping is more accessible. Recording, layering, and altering sounds is faster and cheaper. In terms of organizing my ideas, how I write is different than when I use pen and paper. I do not have to work in a linear manner since I can cut, paste, and move around my thoughts quickly. I can have the computer assist me by taking dictation, reading back to me, and checking my spelling. Also, producing interactive media works and web-based works is only possible for me through these technologies.

AG: How do you choose the technology with which you make your art?

FT: For all of my artworks, I choose and use whatever serves the ideas best. The technology is just part of the container for the artwork. Both content and form are in flux. This is not about imposing fixed forms on to content since both form and content are dynamic. Negotiations between form, content, viewer, and artist are constant. The nature of collaging is that, while I change the context of the materials I choose and use, the work is still mediated through origins, histories, and prior meaning of the found and the made.

38

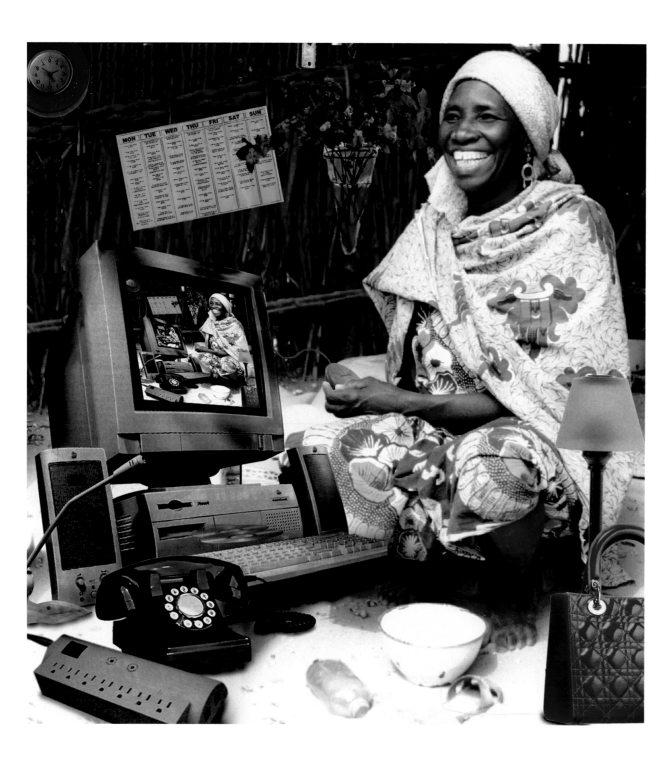

Working Woman, 1997
Computer montage (inkjet on vinyl)
50 × 48 in. (128 × 121 cm)

——DELINDA COLLIER

THE MISCEGENATED INTERFACE

Functionality in Fatimah Tuggar's *Working Woman* and *Broom*

In 1970, two important exhibitions in New York turned to the computational and technological in contemporary art. *Information* at the Museum of Modern Art and *Software—Information Technology: Its New Meaning for Art* at the Jewish Museum both entertained the growing popularity of cybernetics; they both implicitly argued that artists were like computers, giving sets of instructions or codes to be executed.[1] Two years earlier, Jack Burnham, who was involved with both exhibitions, had published *Beyond Modern Sculpture: The Effects of Science and Technology on the Sculpture of This Century*.[2] Compared to Rosalind Krauss's 1977 *Passages in Modern Sculpture*, the books represented a split in the field of contemporary art between those who championed so-called "art and technology" and those who privileged innovations as occurring in conceptual and philosophical modes of art.[3] Tech art was seen by the latter camp as trivial, or worse, beholden to state and corporation.[4] "Too functional," it was separated from conceptual art in much the same way that African art was in the earliest days of European conquest. Like tech art, African art was set outside of aesthetic and art historical debates, all premised on distinctions between the made and the natural, the philosophical and the material. Caught up in the history of colonialism, African art was more obviously part of what

critical theorist Alexander Weheliye calls "racializing assemblages," or the mechanisms that maintain social hierarchies based on race, while tech art has generally accepted race as a stable, essential category, separate from concepts of technology.[5] In this analysis of two of Tuggar's artworks from the mid-1990s, I demonstrate that tech art discourse is borne of miscegenation, a term associated with the difficult, violent history of attempts to maintain racial fictions through segregation. As with African art, interpretations of tech art have been racializing, and tech art itself represents a mixing that corresponds to a strict segregation between "progress" and obsolescence in bodies, concepts, and objects.

———The 1990s saw another moment of interest in tech art as the internet opened to public, proprietary use. A confluence of artists oriented themselves to alternative, "African" histories of tech art and the politics of obsolescence. Mark Dery's now classic 1994 essay "Black to the Future," in which he coined the term Afrofuturism, appeared in the same cluster of years as did Tuggar's photomontages and tech objects and John Akomfrah's influential film *Last Angel of History* (1996). To establish the genealogy of Afrofuturism, Akomfrah collected the stories and work of George Clinton, Sun Ra, Derrick May, Samuel R. Delaney, Kodwo Eshun, and many others. The aesthetic of *Last Angel of History*, with its orange filter, is otherworldly and meant to illustrate the "other side" of tech. Dery stated that "technology is too often brought to bear on black bodies (branding, forced sterilization, the Tuskegee experiment, and tasers readily come to mind)."[6] He concluded that African American science fiction responded to the "alien abduction" of the slave trade. Tuggar's deliberate performance of technologies as artistic media likewise references what John Guillory calls the "dispersion of persons in social space," which, he argues, is a key condition of the media concept.[7] Tuggar's artwork demonstrates how media objects and concepts arose not from abstract migrations, but from diaspora, colonialism, and the black body subjected to labor and experimentation.

John Akomfrah, Still from *Last Angel of History*, 1997
Documentary film, 45 minutes
Produced by the Black Audio Film Collective
Image courtesy of Icarus Films

———— Early in her career, Tuggar was reticent of making art that focused on blackness; she knew that any image of Africans or women in her pictures would "be reduced to race" in the United States-based art world.[8] Indeed, the tendency to read "race" into tech art made by a woman of color is a symptom of a field that sublimates racialization. Tuggar's miscegenated interfaces do not just mix things, bodies, and cultural stylistics to bring the separate category of race into tech, because those were never separate. More importantly, they depict together the basic social and mechanical functions of media objects in propositional scenes representative of power relationships. Tuggar's images, objects, and interactive work can be likened to something art historian Edward Shanken writes about artist Joseph Kosuth's late 1960s conceptual art, that it "investigated the relationship between art and non-art ideas, the vehicles by which they are expressed, and the semiotic networks that enable and delimit their meanings in multiple contexts."[9] The myth of conceptual art, as with cybernetics, was that it was unmarked by culture, race, or gender.

———— As an early adopter of image technology, Tuggar used Photoshop (released in 1988) not necessarily to mimic the jarring juxtapositions of early avant-garde collage, but rather to invent images—photomontages—with a new level of integration. Software, as Lev Manovich argues, results in both mediation and remediation, and each of these functions comprise Tuggar's photomontages.[10] *Working Woman* (1997), for instance, posits two main characters, the laboring African woman and the desktop computer, as coterminous. The mimetic and the functional are interpenetrated. The desktop computer is here fully a multimedia machine with a screen that acts in its cinematic, mimetic history, complete with attached speakers. Next to it is a mid-century telephone (that which the multimedia computer replaces) and a surge protected power strip (that which the computer requires). Other objects in *Working Woman* like the clock and calendar are media that are also replaced or remediated by the computer.

41

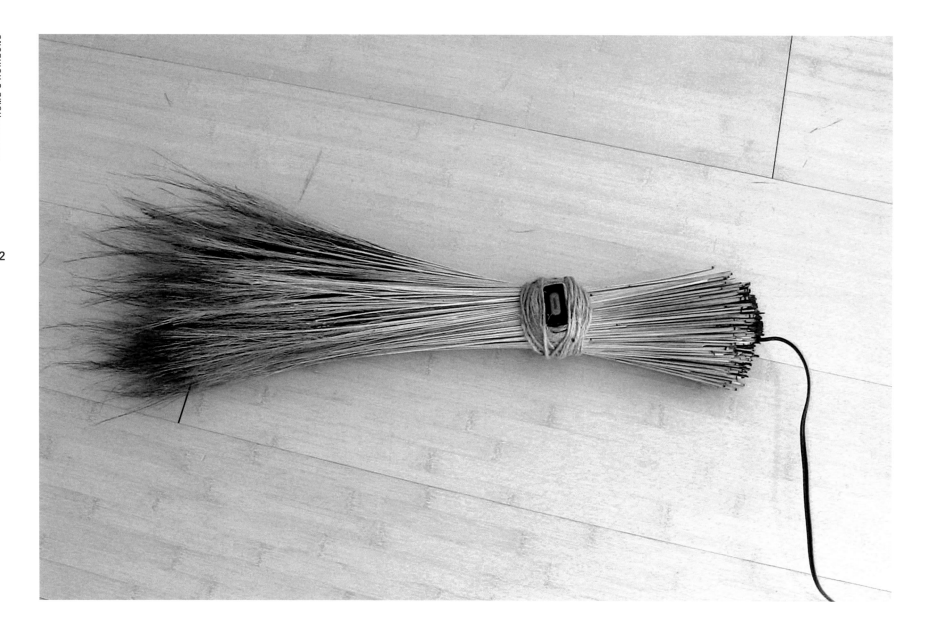

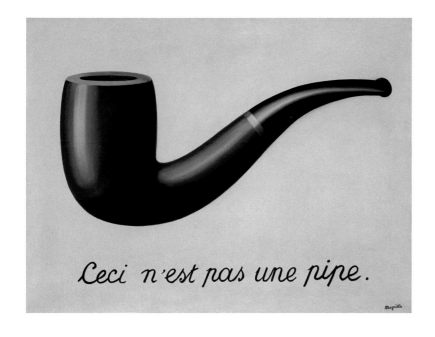

Tuggar's 1990s photomontages are remarkable early examples of digital images that refer to the history of technology. The images are self-referential nearly to the point of being tautological. As the artist herself writes, they are a "circular system of images referencing each other infinitely."[11] It helps to compare Tuggar's digital montages to her "tool" objects, for the comparison allows us to better understand the logic of her use of substitution as a matter of both functionality and representation. The substitution may at first appear to be related to collage, but it has critical differences in terms of the picture as interface; her montages become thresholds instead of picture planes. To use a phrase of Marshall McLuhan's, Tuggar's work maps out the moments where medium becomes message, and when it remains pure information. She tests the neutrality of technology, gently pressing and thus exposing the contours of its supposedly generic objects.

The sound art object, *Broom* (1996) is a simple bundle of hay bound together into a hand broom. Tuggar fitted the handle with a sound chip that contains a recording of the sound of a broom in use; the "swoosh" becomes a sonic representation of a broom. *Broom* is meticulous in its representational economy. The sound of the broom functioning is raised to the level of significance as a physical aspect of the "actual" broom. As a philosophical proposition, *Broom* takes art historical references like René Magritte's *The Treachery of Images* (1928–29)—a painting of a pipe that proclaims it is not a pipe—or Marcel Duchamp's readymades and further challenges the reign of the retinal and the non-functional in modern art. *Broom* asks why Magritte's object cannot be a functional pipe and a representation of a pipe at the same time. These early twentieth-century works by the Dadaists and Surrealists disarticulated the represented and its representation. Tuggar's *Broom*, in turn, calls up a longer history of mediation in the non-West; it conflates the representational and the functional, suggesting that mediation has always been instrumentalized and strange. Extending Duchamp's trick, Tuggar's *The Talking Urinal* stages

43

OPPOSITE
Broom, 1996
Hay broom, electronic sound chip, speaker, power button
24 × 2 in. (70 × 5 cm)

ABOVE
René Magritte, *The Treachery of Images (This is Not a Pipe)*
[*La trahison des images (Ceci n'est pas une pipe)*], 1929
Oil on canvas
Canvas: 23¾ × 31⅞ × 1 in. (60.33 × 81.12 × 2.54 cm)
Framed: 30⅞ × 39⅛ × 3 in. (78.42 × 99.38 × 7.62 cm)
Los Angeles County Museum of Art, Los Angeles, CA
Purchased with funds provided by the Mr. and
Mrs. William Preston Harrison Collection (78.7)
© 2019 C. Herscovici/Artists Rights Society (ARS), New York
Digital Image © 2019 Museum Associates/LACMA
Licensed by Art Resource, NY

the object as a literal portal into a bathroom as a site of socially-engineered reproduction: we hear two women talking about their boyfriends across the bathroom stalls. Again, the functional and the representational collide.

————The mise-en-abyme of the woman and her computer in *Working Woman* suggests a bridge between the representational screen and an interface, what writer and computer programmer Alexander Galloway calls a "transparent threshold."[12] In his analysis of Tuggar's images, art historian Yates McKee quotes Max Ernst on collage: "The coupling of two realities, irreconcilable in appearance, upon a plane which apparently does not suit them..."[13] In Ernst's collages, for example, functional objects are rendered dysfunctional in their juxtapositions, as is the functionality of the picture as a whole. So too was illogical chance the plight of André Breton, who found inspiration in Comte de Lautréamont's exclamation in *Les Chants de Maldoror* (1869): "as beautiful as the chance encounter of a sewing machine and an umbrella on an operating table."[14] On the other hand, Tuggar's images are carefully engineered to make sense by creating a pictorial format generous enough to accommodate different realities. Lest we think this is utopian, Galloway reminds us that "the catoptrics of the society of the spectacle is now the dioptrics of the society of control."[15] The surface is not a single plane of reflection (representation), but "a systemic relation" that is shown in Tuggar's work by images of functional objects and their "photoshopped" appearance. I expect to be able to mouse click on each element of her images as if they were hyperlinks to endless other pages and worlds. Following the logic of late capitalism in the age of digital information, everything can be connected, but the user does not have control over anything—only the illusion of choice.

————If we put some more pressure on the surrealist irreconcilability upon/of the picture plane, it is not a nonsensical juxtaposition that most often occurs in Tuggar's digital images, but rather a substitution that adheres according to the basic function of objects and bodies. Such substitution might present a juxtaposition of visual form, but that occurs as a secondary effect. Tuggar

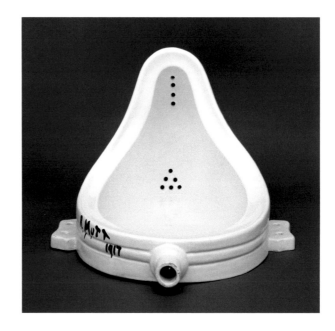

Marcel Duchamp (1887–1968), *Fountain*,
1917, replica 1964
Porcelain
2³⁄₁₀ × 18⁹⁄₁₀ × 24 in. (6 × 48 × 61 cm)
Tate Modern, London, England
Purchased with assistance from the Friends
of the Tate Gallery 1999, T07573
© Association Marcel Duchamp/ADAGP, Paris/
Artists Rights Society (ARS), New York 2019
Photo Credit: © Tate, London 2019

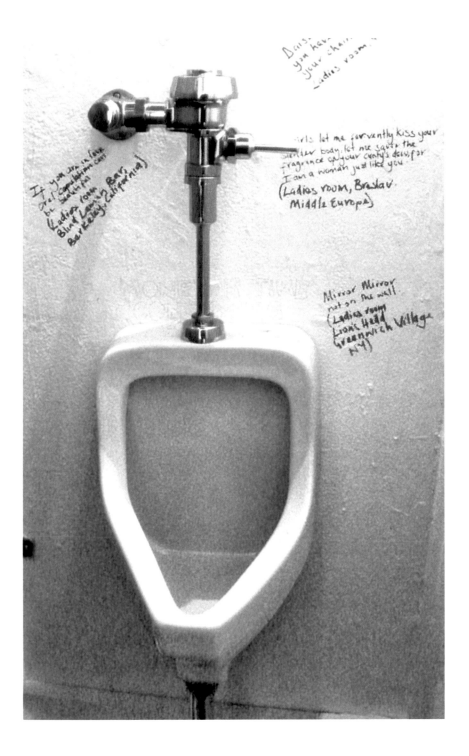

The Talking Urinal, 1992
Bathroom stall walls, urinal, speakers,
audio recording from women's
public bathroom, bathroom graffiti
(excerpts from book), motion sensor
Dimensions variable

indicates this when she writes, "By this I mean that I introduce myriad ways to resolve the challenges of executing ideas by studying and/or using already existing materials, mechanisms, and systems. When I wish to build something that carries out a particular action, first I define the core idea and then figure out what already exists in the world that has the same or comparable action."[16] To inventory just some of what appears in the montages, there are African women's bodies and computers, earthen and enamel pots, thatched fences, train tracks and the Las Vegas strip; there are also a variety of textures, image qualities, shadows, and points of view. I see multiple light sources, scales, and picture opacities created by the various tools of Photoshop (that mimic our old tools): lasso, hand, brush, eraser, and magic wand.

46

———— Tuggar writes that the function of the substitution is to find "comparable" objects to substitute. Then the photomontage is logically closer to an interface, the threshold model of the two-dimensional surface, which Galloway argues has always haunted the classical planarity of Western representation.[17] Likewise, Tuggar's objects/sculptures and interactive screen art all share an orientation to the history and philosophy of tools. Taken together, Tuggar's early digital images abstract functionality in order to find its essence, to bypass the usual form things take according to capitalist morphology. The shapes that "innovative tech" produces protect proprietary functions, according to those who create "black boxes" of mysterious technology that program us.

———— So, while functionality is essentialized, miscegenation also acts as a vehicle for the poetics of Tuggar's montages. The dispersion of people, and their subsequent arrangements along racial hierarchies, emerges as a fundamental condition of medium and conquest.[18] Tuggar's work highlights the basic use of medium as a palliative for people dispersed in space, and whatever absurdity that obtains from the mixture of the forms (bionic arms, clay pots, varying architectures, etc.) is due to our full immersion in a culture of stylized technology. The conflation of technology and capitalism has become so naturalized that it

is difficult to detect what is being enhanced by a new technology, a new medium. In fact, the familiar quote by McLuhan that the "medium is the message" is less about medium specificity, as it is so often used to indicate. Rather, McLuhan asks what new worlds a medium makes possible by being naturalized to the point of invisibility. He gives us the example of the light bulb and all of the aspects of life that come after it like night baseball and surgery, asking whether artifacts replace previous conditions or merely enhance them.[19] The activities may seem to be the content of the medium, he writes, but we fail to look at the electric light bulb because it makes way for content. The "medium" of the lightbulb is a vehicle of enormous social change via the collapsing of space and time.

————Tuggar's critique of notions of progress in technology makes visible what is naturalized to the point of invisibility, opening to the possibility of an entire ecology of things and substances that mediate what we consider "natural" and "made." In *Working Woman*, this is beautifully illustrated by the appearance of two types of fractals in the picture: the figure of the woman repeated ad infinitum on/in the screen and the scalable geometric design used to construct the Saheli woven fence in the background of the image. Tuggar's pairing of fractals recalls Ron Eglash's reflection, "Whether we make our graphs on a computer screen or a straw screen doesn't matter, as long as we get the right answer."[20] Eglash's concern in mathematics is also one of design, and design and art are only ever delinked when there is a societal fiction being perpetuated. The choice between the made and the natural, the functional and the non-functional, is no choice.

48

1. *Information* was on view at the Museum of Modern Art from July 2 until September 20, 1970 (Exhibition webpage: https://www.moma.org/calendar/exhibitions/2686). The Jewish Museum held *Software—Information Technology: Its New Meaning for Art* from September 16 until November 8, 1970. Kynaston L. McShine, ed. *Information* (New York, NY: The Museum of Modern Art, 1970). Karl Katz, et al., *Software—Information Technology: Its New Meaning for Art* (New York, NY: The Jewish Museum, 1970).

2. Jack Burnham, *Beyond Modern Sculpture: The Effects of Science and Technology on the Sculpture of this Century* (New York, NY: G. Braziller, 1968).

3. Rosalind Krauss, *Passages in Modern Sculpture* (Cambridge, MA: MIT Press, 1977).

4. Art historian David Carrier writes that Burnham, "a muddled thinker, championed the wrong new art," articulating an implicit suspicion of tech art in the circles that would come to dominate the discourse of art history in the West, particularly by writers affiliated with the journal *October*. David Carrier, *Rosalind Krauss and American Philosophical Art Criticism: From Formalism to Beyond Postmodernism* (London: Praeger, 2002), 7. In his review of the book, Norbert Lynton writes that artists more often demonstrated their naiveté with science when they tried to engage it in their work, showing the educational gap between art and science. He then suggests that Burnham's account is only held together by a "skewer of progress," which adds another layer to the difference between his and Krauss's thinking. "*Beyond Modern Sculpture* by Jack Burnham (review)" *Leonardo* 3, no. 1 (January 1970): 108–109.

5. Alexander Weheliye, *Habeas Viscus: Racializing Assemblages, Biopolitics, and Black Feminist Theories of the Human* (Durham, NC: Duke University Press, 2014).

6. Mark Dery, "Black to the Future: Interviews with Samuel R. Delany, Greg Tate, and Tricia Rose" in Mark Dery, ed., *Flame Wars: The Discourse of Cyberculture* (Durham, NC: Duke University Press, 1994), 180.

7. John Guillory, "Genesis of the Media Concept," *Critical Inquiry* 36, no. 2 (Winter 2010): 357. As far as I can tell, Guillory did not intend this phrase to extend to the large-scale catastrophe of the slave trade; I am extending his argument's reach.

8. Tuggar in an interview with Gary Sullivan, "Interview: Fatimah Tuggar," *readme* 4 (Spring/Summer 2001), accessible: http://home.jps.net/~nada/issuefour.htm.

9. Edward Shanken, "Art in the Information Age: Technology and Conceptual Art," *Leonardo* 35, no. 4 (2002): 435. Shanken has written extensively about the supposed split in contemporary art between conceptual and tech art.

10. Lev Manovich's "Inside Photoshop" is helpful in understanding the new and old functionality of Photoshop as it appeared within the growing digital media ecology. He writes that, as software, Photoshop "became synonymous with 'digital media….'" In *Software Takes Command* (New York, NY: Bloomsbury, 2013), 124.

11. Fatimah Tuggar, "Montage as Tool of Political Visual Realignment," *Visual Communication* 12, no. 3 (2013): 375.

12. Alexander Galloway, "The Unworkable Interface," *New Literary History* 39 (2009): 931. He writes, "Reflective surfaces have been overthrown by transparent thresholds. The metal detector arch, or the graphics frustum, or the Unix socket—these are the new emblems of the age."

13. Max Ernst quoted in Yates McKee, "The Politics of the Plane: On Fatimah Tuggar's *Working Woman*," *Visual Anthropology* 19 (2006): 417.

14. Comte de Lautréamont, *Les Chants de Maldoror* (Paris: En Vente Chez Tous Les Libraires, 1869).

15. Galloway, "The Unworkable Interface," 931.

16. Fatimah Tuggar, "Methods, Making, and the West African Influences in the Work of Fatimah Tuggar," *African Arts* 50, no. 4 (Winter 2017): 14.

17. Galloway writes extensively of the two choices of depth and surface in visual methodologies, suggesting that the choice was always spurious. Galloway, "The Unworkable Interface," 932.

18. On the coterminousness of Surrealism and ethnography, see James Clifford, "On Ethnographic Surrealism," *Comparative Studies in Society and History* 23, no. 4 (October 1981): 539–564.

19. Marshall McLuhan, *Understanding Media: Extensions of Man* (1964) (Cambridge, MA: MIT Press, 1994), 8–9.

20. Ron Eglash, *African Fractals: Modern Computing and Indigenous Design* (New Brunswick, NY: Rutgers University Press, 1999), 74.

50

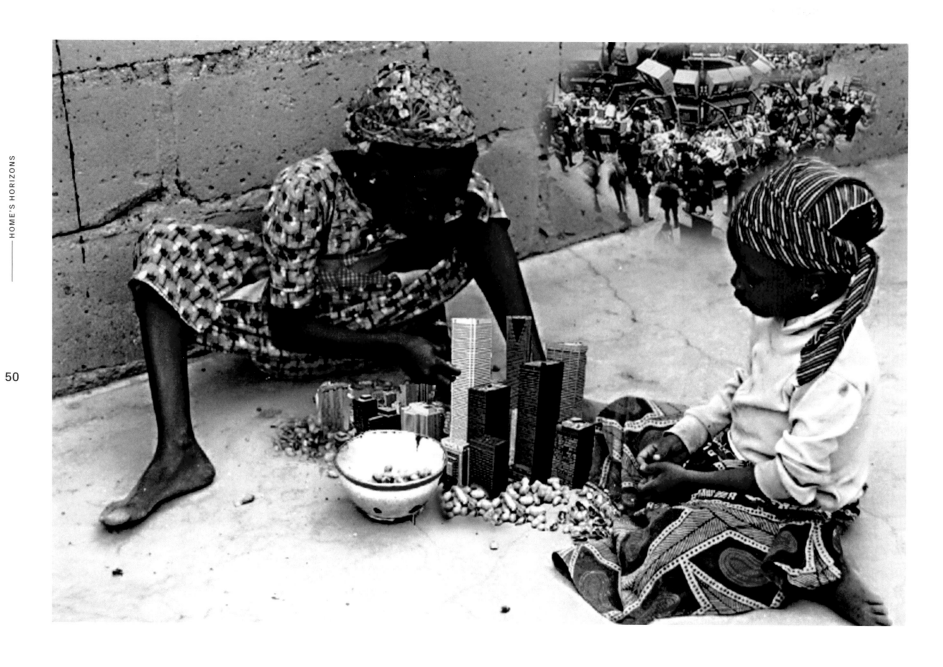

Sibling Rivalry, 1995
Computer montage (inkjet on vinyl)
20 × 30 in. (50 × 76 cm)

THE NONLINEAR TEMPORALITIES OF FATIMAH TUGGAR'S MEDIA ART

In *Sibling Rivalry* **(1995), two young Nigerian girls** play a game of Monopoly with major transnational economic and political stakes. They vie for Manhattan skyscrapers representing property and global corporations, with Wall Street captive to their gamesmanship. The girls sit in a courtyard planning their next move and loom large over the trophies of their conquest. They are world makers in this photomontage by Nigerian-born, United States-based media artist Fatimah Tuggar. The scene represents recurring themes and key elements of Tuggar's art and her use of play to address the nonlinear temporalities of technology, colonialism, and racial and gender subjugation and how these forces impact planetary sustainability and notions of human progress.

——— For over two decades, Tuggar has produced works involving various technologies that examine histories of race, gender, and technological commodities and discourses. Before Facebook and SnapChat, before smartphones were common devices owned by most consumers, Tuggar was already deeply involved in an investigation into how technology shapes our social practices and mores—and more intimately, our experience of home and the domestic sphere.[1] Technology is the recurring subject of her art, and also provides the tools by which she creates. Over the course of her career, she has explored

51

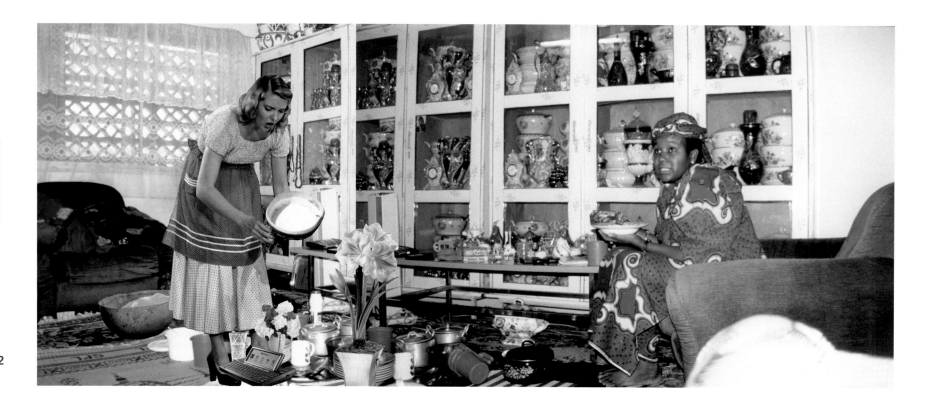

technology and culture while experimenting with photo collage, video collage, appropriation of archival film footage, interactive media sites, and multimedia installations, public art, and media technology.

————Tuggar considers the experience of living in a world of extractive capitalism in the contemporary era shaped by neoliberal economics and geo-political struggles over resources and borders that produce massive precarity for non-white, marginalized, poor, and rightless people across the globe. It is also a world in which technology is promulgated as the solution to countless problems, as technocrats frequently unveil new devices to a "global community" under the guise of equal access and outcomes for all. While some software engineers, CEOs, and technocrats make claims about technology's abilities to advance human societies, Tuggar explores other narratives of what has been described as an increasingly networked and interdependent world.[2]

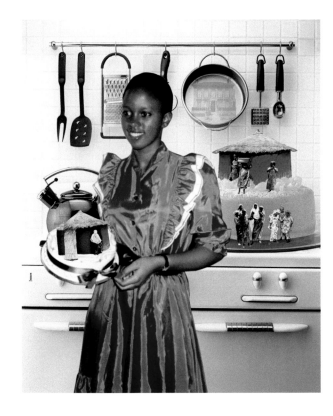

————To investigate how race and gender shape perceptions of technology, space, and nonlinear development, Tuggar often centers black Muslim women from Nigeria as the subjects of her collages and montages. She combines late twentieth-century video footage and photographs taken in Nigeria with mid-twentieth-century archival representations of technology and gendered forms of consumption from the United States, such as Cold War-era commercials selling soap and other domestic products geared toward white middle class American women. Her framings resist simple juxtaposition and instead create nuanced and richly textured scenes, as with the computer montage *Lady and the Maid* (2000). In a sitting room of a domestic interior where one wall consists of a cabinet of ornate dishes, a contemporary Nigerian woman sits in a plush chair holding a bowl of food while a blonde white woman in an apron from a mid-twentieth century stock film bends over the table, appearing to labor. We do not know who the lady is and who the maid is. While the identities of both are indeterminate, the spatial proximity—occupying the domestic scene together—points to the regional and historical specificity of racial and gender categories. The photomontage and its title also emphasize how forms of labor reproduce such categories.

————Tuggar's work refutes a hierarchy of technology and instead reveals multiple modes of human innovation and manipulation of resources to foster notions of the domestic and quotidian practices that maintain individuals, families, and societies. *Cake People* (2001) can be read as an indictment of how technological commodities produce heightened levels of consumption, cultural imperialism, and energy use. The photomontage consists of layered representations on different scales: a young black woman stands and smiles in a kitchen interior. She wears a fancy dress, one fitting for a ceremony or celebration. Behind her is a stove. On it sits a cake designed with a miniature of a thatched roof, clay-walled home; small-scaled people stand in front of the home and along the edges of the cake. The woman also holds a cake with another tiny

53

OPPOSITE
Lady and the Maid, 2000
Computer montage (inkjet on vinyl)
108 × 45 in. (274 × 115 cm)

ABOVE
Cake People, 2001
Computer montage (inkjet on vinyl)
48 × 58 in. (121 × 147 cm)

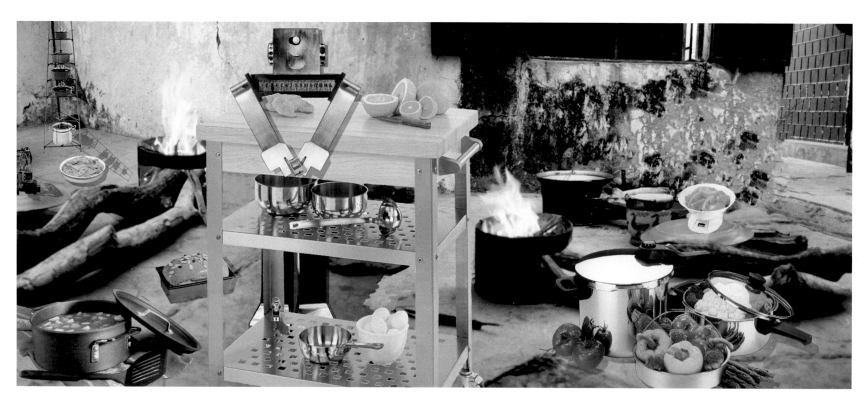

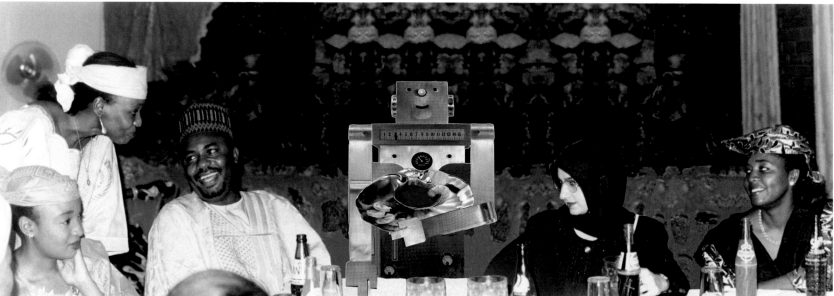

home and figure as she looks outside of the frame of the image and appears to present the cake as an object of display to guests or an audience who are not pictured. *Cake People* simultaneously comments on the importation of devices, like the stove, to produce certain forms of consumption, like the cake, as it also comments on Western desires to consume certain colonial visual tropes of African women.

——— In other works, like *Robo Makes Dinner* (2000), Tuggar imagines an anthropomorphic metal robot, akin to the robotic character in the 1960s television cartoon *The Jetsons*, as the protagonist of her techno-fantasy, a scene both deeply familiar and playfully ironic. In it, Robo, as an anachronistic figure of techno-futurism in the early twenty-first century, leans across a wooden kitchen island surrounded by fresh vegetables and kitchen utensils. The robot smiles as it prepares a meal. *Robo Entertains* (2001) extends her investigation of technology, consumption, and colonial discourse through humor and the suturing of visual images and narratives that are often framed as binaries of "haves" and "have nots."[3] Here, Robo hosts a dinner party for guests presumably differently positioned in the Atlantic world, and from former empires and post-colonies. A recurring character, Robo appears in various of Tuggar's artworks as a protagonist of a post-colonial and ironic fantasy of Afrofuturism. The robot provides a gendered form of care: offering nourishment, welcoming, and entertaining. The robot is a deeply familiar and familial character, and playfully outdated. It is an amalgamation of various consumer trends, technological experiments, and conversations and debates about the good life. For example, does technology relieve certain domestic burdens, especially for women, or does it lead to higher levels of consumption, waste, and equality? What happens to our previous dreams and visions of techno-utopias? Where do our outdated and previous technological models go to die? These questions gesture at the complex and multivalent approaches that Tuggar takes to investigate technology, culture, race, gender, nation, and commodification.

55

OPPOSITE, TOP
Robo Makes Dinner, 2000
Computer montage (inkjet on vinyl)
108 × 45 in. (274 × 115 cm)

OPPOSITE, BOTTOM
Robo Entertains, 2001
Computer montage (inkjet on vinyl)
48 × 140 in. (121 × 357 cm)

———— Critics have noted how Tuggar creates digital scenes that move beyond binary understandings of technological divides and cultural and racial distinctions. Her art visualizes the complex relations that technology represents and animates especially between West Africa and the United States and Western Europe.[4] Technology is both object and tool for Tuggar to explore consumption, desire, and positionality as local, regional, and global circuits. Writer Hélène Selam Kleih writes, "African is not a homogenous identity—it is one affected by factors: environmental, technological, socio-economical. Collaged images of black Muslim women wearing traditional dress overlay those of white middle class women; highlighting the distinctions within gender: where tropes of class, race and religion may differ without colliding."[5]

56

———— Tuggar's practices have offered multiple interventions into contemporary aesthetics, technology studies, post-colonial studies, and gender theory, while offering pedagogical practices for research-driven art that responds to art spaces and educational institutions with which she has been affiliated. In *One Blithe Day* (2010), an installation in Durham, North Carolina that incorporated art, design, environmental planning, and resource extraction, Tuggar involved audiences as participants to consider "the role of water in human life." As in much of her recent work, she presented various landscapes, environments, and scenes in conjunction with number of options for participants to engage in practice, consumption, and consequences. The title itself encouraged participants to consider the privilege of ignorance that some in the global sphere are afforded when it comes to resource extraction and consumption. One screen presented viewers with a close up of a glass of water with a straw and lemon. Another shows a swimming pool. Other scenes included a saline drip in a hospital and a series of streams and bodies of water with evidence of pollution—bottles and trash in streams. As I have written elsewhere, her interactive projects, including the new installation *Deep Blue Wells*, assume multiple viewing positions, technological practices, and points of access for her audiences/participants.[6] Her

Details, *One Blithe Day*, 2010
Panoramic screen details, top to bottom:
Trash in Creek, *Gas Station*, *Oil in Creek*
40 monitors (video and still images), infrared
web IP cameras, projectors, computer, ethernet hub
Perkins Library, Duke University, Durham, NC
Funding: Office of the Vice Provost of the Arts
Senior Water Quality Technician: Jonathan Baker
Stormwater/Environmental Educator: Laura Webb Smith
Pollution Prevention Coordinator: Abigail Ferrance-Wu
Water Resources Engineer: Michelle Woolfolk
Water Quality Specialist: Robert Louque
City of Durham Stormwater Services Division
Link Media Wall, Duke University,
Teaching and Learning Center
Duke University Visual Studies Initiative

digital video pieces and photomontages generally have touched the crisis of representing transnational subjectivities in an increasingly globalized and technologized world.

———*Transient Transfer* (2000), another interactive work, facilitates collaborative design as a praxis of future world making through the media of a website and posters printed from the online content. Originally commissioned by the Bronx Museum of the Arts and the Public Art Fund for the exhibition *Street Art, Street Life* (2008), the work consists of various scenes and "landscapes" of the borough of the Bronx, which is among the zip codes with the highest poverty rates in the United States. While dominant representations of the Bronx are often framed through narratives of deprivation and lack, the vibrant, everyday cultural life and rich diversity of the borough often go overlooked. With *Transient Transfer*, Tuggar's transnational inquiries take a localized approach as she animates images, sounds, and scenes of playful, quotidian life, including ice cream carts, jumping dogs, moving subway trains, hair stylists at work, and water flowing from fire hydrants. The project includes an online user interface that allows viewers to build visual and sound collages based on the data that Tuggar has accumulated. Viewers can invent new visual narratives and play with various temporalities as they collage their visions of street life in the borough. In this way, Tuggar has worked collectively with residents of the Bronx and people from around the world to create public art collages, some of which were installed as posters at NYC bus stops. The project continues to grow through the website, which is still active.[7]

———Tuggar's art is in conversation with Afrofuturism, a late twentieth- and early twenty-first century movement among artists, writers, and thinkers of the black diaspora. Afrofuturism engages in forms of culture-making that incorporate black vernacular cultures, African cosmologies, styles, and symbols with a sustained interest in interstellar activity and sci-fi explorations of racially inflected techno-societies that refute Western colonial discourses and mandates.

Installation photograph, *Transient Transfer*, 2000
Architectural façade, plasma screen, touch overlay, speakers, computer, fans, animated flash web-based interactive content
Bronx Museum of the Arts, The Bronx, NY
Coding: Shaun Mackey
Interface Design and Media Integration: Bill Todd
Exhibition Design: Michael Lightsmith
In Kind Donations:
Interactive Plasma: Panasonic Professional Display Company
Display Experiments R and D: Imaging Systems Technology
Installation Technology Integration: kNot Theory
A/V Consulting and Testing: New City Video Staging
Vikuiti Material: 3M Optical Systems Division

58

Yet, Tuggar's oeuvre is one that resists a linear temporality or a notion that futurism is better or more progressive than the current moment or the past. About this Tuggar states, "While Afrofuturism and science fiction are interested in fantasy projections into the past and future, I am anchored by what I call an 'alternative imaginary.' I focus on the resources currently available in the world and then imagine through both my medium and my process how I can suggest another possibility."[8] She also refutes any notion that new or advanced technologies are the domain of European or American societies. One approach to her nuanced understanding of a nonlinear temporality is her repurposing of historic and archival ethnographic and voyeuristic imagery of Africa. She uses such material to query about the desire and impulse of various societies to envision technological innovation as "freeing," that is freeing up time, freeing women from domestic chores, freeing post-colonial people from relationships and theories of dependence with European and American nations that forcefully promulgate systems of global capitalism that reproduce inequality. She interrogates the positivist notion of time as measured through technological advancement and the expansions of globalized capitalism, as seen in the child's play of *Sibling Rivalry* (1995). By actively engaging participants—instead of passive viewers—who are differently positioned economically, racially, nationally, and otherwise, Tuggar does not efface or erase distinctions, but instead highlights geographic, racial, gender, and temporal variation to imagine new technological landscapes of sustainability and social practices not based in extraction and over-consumption.

1. The first smartphone was invented in 1992, and the term "smartphone" was coined in 1995.

2. See Tom Vanderbilt, "Elon Musk and the Dangerous Cliché of the Disruptive Visionary," *Wired UK* (August 13, 2018): https://www.wired.co.uk/article/tesla-elon-musk; Jemima Kiss, "Google CEO Sundar Pichai: 'I don't know whether humans want change that fast,'" *The Guardian* (October 7, 2017): https://www.theguardian.com/technology/2017/oct/07/google-boss-sundar-pichai-tax-gender-equality-data-protection-jemima-kiss

3. For a more detailed analysis of these works, see Nicole R. Fleetwood, "Visible Seams: The Media Art of Fatimah Tuggar," in *Troubling Vision: Performance, Visuality, and Blackness* (Chicago, IL: University of Chicago Press, 2011).

4. See Elizabeth Janus, "Fatimah Tuggar: Art and Public," *Artforum International* 39, no. 5 (January 2001): 147.

5. Hélène Selam Kleih, "Fatimah Tuggar: Art Manufactoriel," *Coeval*: https://www.coeval-magazine.com/coeval/fatimah-tuggar

6. Fleetwood, "Visible Seams: The Media Art of Fatimah Tuggar," 2011.

7. Fatimah Tuggar, *Transient Transfer*, 2000: http://transienttransfer.com/index.html

8. Fatimah Tuggar, "Methods, Making, and West African Influences in the Work of Fatimah Tuggar." *African Arts* 50, no. 4 (2017): 12–17.

Sketch for 3-D animation of indigo
molecule, still from AR content in
Deep Blue Wells, 2019

———— JENNIFER BAJOREK

FATIMAH TUGGAR: DEEP BLUE RECODINGS

Fatimah Tuggar's work knits together images, objects, and sounds from different geographic sites, cultural spaces, and social spheres. In this way, the artist plays with, and works through, multiple and overlapping positions and oppositions between seemingly disparate terms: African, American, and European, urban and rural, domestic and commercial, intimate and communal, private and public, local and global, particular and general. In so doing, Tuggar's work deftly dismantles and recomposes the relationships between these terms, exposing the secret and subterranean lines of communication that connect them and illuminating relationships that are all too often distorted or rendered invisible in the contemporary global image ecology—whether by the operations of global capital, neoliberalism, and their colonial antecedents, or by cultural and aesthetic ideologies that are embedded in specific forms of labor and, by extension, in specific tools and technologies.[1]

————Indeed, Tuggar's work is distinctive for its central concern with technology, a word and concept that corresponds, for the artist, to both method and theme. Among the methods that she has used, from the earliest days of her career, for visualizing or otherwise making manifest the borders erected by European colonialism, Euro-American cultural hegemony, white supremacy, capitalist relations

61

of production, globalization, and associated ideologies is the incorporation of specific technologies, including but not limited to media and communications technologies, in her work—old and new, "primitive" and "high-tech," analog and digital. Starting in the 1990s, Tuggar's early and sustained engagement with the question of technology led to her canonization, by critics and other interpreters, as an avatar of Afrofuturism in the contemporary art world. However, these interpreters—including, most notably, Alondra Nelson, in her seminal 2002 special issue of *Social Text* on "Afrofuturism"—have focused their energies overwhelmingly on Tuggar's photomontage and video and have paid less attention to her sculptures, which the artist also refers to as her object-based work.[2] The Afrofuturist label, although contested by the artist, has stuck and is likely to become only more tenacious in view of her growing body of work in digital and new media.[3]

————In the late 2000s, the artist undertook a series of novel interactive works: *Transient Transfer* (2008), *Desired Dwellings* (2009), and *One Blithe Day* (2010). Generated from networked platforms, *Transient Transfer* and *One Blithe Day* included large-scale public installations consisting primarily of collages rendered as two-dimensional images displayed on screens or as printed posters. *Desired Dwellings* is a Virtual Reality (VR) installation in an immersive (CAVE) environment.[4] These interactive works extended the artist's concern with cultural as well as technological fusion, collage, montage, and assemblage into new digital spaces, and they combined new technologies with evolving forms of user interaction, participation, and collaboration. Whatever we may make of the debates about Afrofuturism, Tuggar's interactive media work has been characteristically ahead of its time in terms of its novel incorporation of digital technologies, and the artist has persistently (re)placed Africa and Africans at the center of her technological investigations.

————This essay examines certain through-lines running from Tuggar's object-based work (dating from 1996) to her latest work in interactive media. In addition, it explores the materiality of different forms of labor, including but not limited to

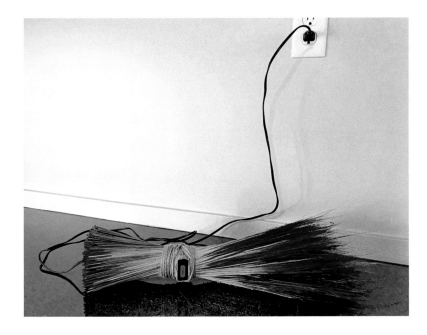

Broom, 1996
Hay broom, electronic sound chip, speaker, power button
24 × 2 in. (70 × 5 cm)

artistic labor, through a reexamination of the artist's use of strategies of collage, montage, and assemblage, which have already been meticulously documented in the scholarly literature on her image-based corpus. A sustained reflection on the ties that bind labor, the African diaspora, and digital technologies seems particularly relevant when it comes to Tuggar's VR and Augmented Reality (AR) work—and especially when it comes to *Deep Blue Wells* (2019), a mixed (including new) media installation about the history and contemporary situation of the indigo dye wells in the city of Kano, Northern Nigeria, realized by the artist as a commission for this exhibition.

1. Power/button

Through her sculptures, Tuggar frequently raises questions about artistic labor. This work also frequently raises questions about other forms of labor, including those not usually associated with art-making. The ability of her sculptures to tackle this diversity of forms of labor, abstract as well as concrete, domestic as well as artistic or industrial, productive as well as reproductive, stems from their interrogation of quotidian experiences of embodiment—an interrogation that is often carried out through their exploration of mundane household objects and through their virtual invocation of the specific sonic, kinetic, or visceral (a term I borrow from the artist) sensations that are associated with those objects' use.[5]

————Take, for example, the sculpture *Broom* (1996). When a button on the broom is pressed, you hear the sound of a broom swooshing. No one is sweeping, yet we all recognize this sound. We may find ourselves wondering about the labor, perhaps also the pleasure, of sweeping. Who exactly does our sweeping? Already the unity of this "we" is here subject to scrutiny, inflected by the power relations encoded by domestic labor, and by the social and economic disparities entailed by the division of reproductive from productive labor in contemporary capitalist societies. Upon further reflection, we cannot fail to notice that the material and sonic specificity of the whisk broom—a "low-tech" model rarely seen

63

in contemporary urban contexts in the "rich" countries of the West and North—is matched by that of the electronic sound chip from which the swooshing issues: a relatively "high-tech" digital sound recording and playback device, albeit one that is already outdated by several generations (and that was replaced, shortly after the work was made in the 1990s, by the MP3). The fact that the electronic sound chip, as a recording and playback technology, has been eclipsed, today, by other, newer technologies, only heightens our awareness of the multiple axes on which the sculpture operates, and the complex ways in which it knits together technological sophistication with simplicity, technological evolution with obsolescence.

————Other scholars have written at length about Tuggar's use of specific artistic strategies and techniques—including collage, assemblage, montage, bricolage, layering, compositing, mixing, remixing, and what one scholar, Nicole R. Fleetwood, has aptly identified as "suture"—to dismantle a host of social and cultural hierarchies and related oppositional logics.[6] Fleetwood and others, including Delinda Collier, Elizabeth Hamilton, Yates McKee, and Nelson, have analyzed the ways in which Tuggar's work employs these techniques to explore complex configurations of race, class, gender, labor, and globalization in relation to power, often through its unexpected combination of images and objects, drawn from different sites and spaces and incorporating different technologies.[7] These same techniques are in ample evidence in *Broom*, in which, we may now see more clearly, the materials—a handmade whisk broom, an electronic sound chip, a power button—are remixed. The formal description of the work reads "hay broom, electronic sound chip, speaker, power button," calling our attention both to the sculpture's own materiality as an object and to that of the diverse forms of art, artisanship, and/or labor that went into its making.[8] It is through this remixing in the sculpture that Tuggar raises questions about certain forms of labor and attendant power relations, on multiple planes of experience and on multiple geographic and geopolitical scales.

————If the handmade whisk broom is rarely seen (or heard) by denizens of London or New York, it is frequently seen and used by residents of Dakar, Manila, Moscow,

Inna's Recipe, 1999
Computer montage (inkjet on vinyl)
114 × 96 in. (365 × 243 cm)

64

Voguish Vista, 2012
Computer montage (inkjet on vinyl)
72 × 50 in. (152 × 91 cm)

Abuja, Bamako, or San Salvador. At the same time, for the middle-class woman or head of a bourgeois household in any one of these cities, the broom may not be wielded by her, but rather by another person, more often than not another woman, whom she pays to do her sweeping. And, for the middle-class woman in London or New York, the chances are extremely good that that person, more often than not another woman, will come from one of these other places. Articulating an experience of domestic space and of embodied sensation (the sound of swooshing) with a system of abstract relations (the labor market, local and global), the low-tech with the high-tech, the labor of social reproduction (housework) with productive labor (waged labor), the visceral with the virtual, *Broom* confronts the viewer, on the one hand, with an elegantly simple object and, on the other, with a dense nexus of questions about social, gender, and family relations, as well as questions about the forces organizing North-South political relations (which are also relations of production) under industrial and post-industrial capital.

2. Deep Blue Wells

Also characterized by techniques of collage, assemblage, and montage, Tuggar's new media work exhibits a similar concern with cultural and technological fusion, mixing, and remixing. Yet these things often manifest themselves to the viewer in ways that are markedly different from in her other work. One reason for this may be that, in digital media, these techniques can no longer be conceived as "secondary" and have rather become the primary processes through which images are generated. In addition, these works, like all works realized in digital media, can make the labor that went into their own production seem more virtual or more abstract, and in this one sense more elusive. And when we think here of labor, we must think of the artist's own labor as well as the artisanship and labor that went into the artwork's various component parts, including the labor done by its coding and design teams. This becoming-virtual of labor, or of certain types of labor, in the new media work may take place even as the new media work renders the

65

user's own actions—her labor?—in the virtual environment, simultaneously, more visceral or embodied.

————This paradoxical becoming-virtual and becoming-visceral of labor is a distinctive feature of Tuggar's 2009 VR work, *Desired Dwellings*. The immersive digital environment provides the user with an opportunity to enter into six different types of dwellings: a West African compound, an urban house, a New York City apartment, a room in a war-torn Liberia (this dwelling was generated with photographic images drawn from the UN Human Rights Archives), a high-tech Japanese apartment, and a cardboard box. As the user moves through and between these different environments, she can select a series of different ordinary household objects and put them down in any one of the dwellings. The user must reflect on what homes and the tools within them might look (or feel) like in different parts of the world: water containers, toilets, beds, storage units, and means of decoration and of entertainment. The user thus engages with specific forms of labor, leisure, and pleasure as she makes decisions about which dwelling she will enter and which objects she will interact with there. *Desired Dwellings*, like all of Tuggar's work in digital and new media, thus presents the user with a series of interactions and experiences in a fun-house mirror maze of her own participation in late-stage capitalism, with its evolution of new digital media technologies under conditions of contagious virtualization and ongoing financial and economic globalization. At the same time, the work proffers a rare counterweight to dominant depictions of the supposed benefits of capitalism in the world, in part by connecting the user, through these technologies, to dwellings, and experiences of dwelling, in different places.

————In the case of *Deep Blue Wells*, Tuggar's new installation, which incorporates digital media in the form of AR, the work relies heavily on actual objects that seem, at first glance, to be drawn from the analog world, most notably the indigo-dyed textiles that line the gallery walls. The indigo dye wells of Kano, Nigeria have been in use since 1498, but they have, in the past two decades, seen curtailed production and risked closure due to economic competition from

ABOVE
Preparatory model for *Deep Blue Wells*, 2018

OPPOSITE
Desired Dwellings, 2009
Interactive full immersion VR (virtual reality),
Duke immersive Virtual Environment,
Duke University, Durham, NC
Coding: David J. Zielinski
Content Management: Holton Thompson

66

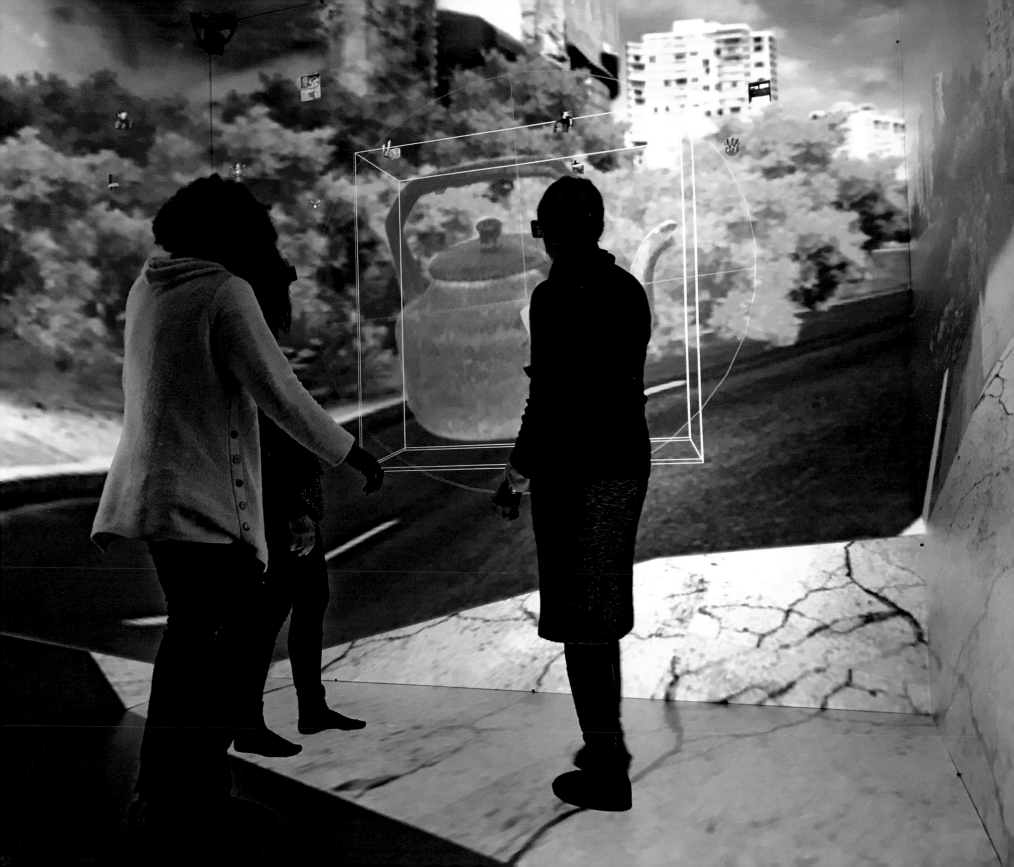

new, digitally-simulated indigo "dyeing" techniques now used in industrial textile production in China.[9] The history and present-day situation of Kano's wells are brought into contact, and to life for the user in the gallery, through archival and contemporary images (still and moving) of the site and of the people and activities surrounding it. These images are presented to users through an application on mobile phones and tablets, activated by a code embedded in the textiles. Through these images, as well as through sculptural elements of the installation, including, most notably, three-dimensional sculptural recreations of the wells, chemical and other dimensions of indigo dyeing are made manifest in the work, as are cultural, economic, and political dimensions of the indigo trade. Tuggar has explained that AR allows the viewer to experience things that are not actually possible to experience in physical gallery space, thus opening up new encounters for the user: contemporary, historical, and imagined.[10]

─────── The user interactions that are constitutive of *Deep Blue Wells* draw on images, objects, and sounds that, through their mixing and remixing, result in alchemical transformations of the objects (in this case, textiles) displayed in the gallery. At the same time, indigo dyeing extends beyond the textiles themselves and consists of a series of sophisticated technologies and technical processes. The dye is itself produced through a technical process requiring expert knowledge. The indigo in Kano's dye wells is the condition of possibility of a whole series of networked people, places, and objects. Indeed, for centuries, indigo was central to the trans-Saharan trade. From there, it followed the West African diaspora in the wake of its centuries-long dispersions to the Americas, thus becoming a matrix of a vast global trade in other technologies, cultural knowledge, and objects. I wish to underscore that there is no myth of origins or origin story about indigo here. There is, rather, diaspora, and a dissemination—along with plants, dyes, and textiles—of African artisans and their specialized cultural knowledge with regard to using and producing these plants, dyes, and textiles, across the globe, even as their contemporary counterparts have continued to create in Kano.

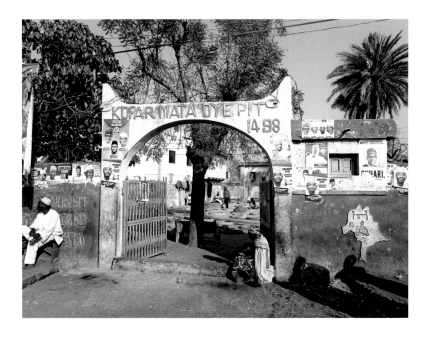

Gate to Kano tie-dye pits, still from
AR content in *Deep Blue Wells*, 2019

————*Deep Blue Wells* extends and deepens Tuggar's preoccupations with craft, artisanship, and "traditional" technologies or tools of making. These are deepened (rather than simply extended) insofar as the work functions as a kind of digital-virtual-immersive-interactive archive of indigo dyeing techniques and practices in Kano. In addition to an installation work with AR components, the work becomes a kind of critical-interactive-digital cultural heritage preservation project. The images, objects, and sounds, archival and contemporary, make visible and commemorate the hand, and the labor, of black cultural producers. Mixed and remixed through, and made available through digital applications, the work opens up as-of-yet unexplored linkages between Africa, its diaspora, and the digital, making more tangible for the user both terms' constitutive relationship to coding and recoding, their inherently networked and distributed properties, and their propensity for dissemination and recombination.

————Also worth underscoring, and distinguishing it from Tuggar's VR work, is *Deep Blue Wells*'s expansion of the opportunities for collaborative viewing, conversation, and interaction *among* users in the gallery. This is a capacity, arguably already native to AR technology, that is here amplified by Tuggar's decision to use an application-based digital technology installed on the hand-held devices many of us now carry everywhere: mobile phones and tablets. The work thus not only collages images, objects, and sounds in time and space, but it allows users to share their looking and listening in the gallery and, in so doing, to collaborate and make meaning with each other, even as they are interacting with the textiles and augmented reality content in the gallery. The shared experiences, collaboration, and interactions become, perhaps, yet another kind of labor: the work of re-imagining our relationships to one another, to these objects, and to history. *Deep Blue Wells* ultimately invites the user to consider the interweaving of the trans-Saharan trade with the Atlantic trade that, it turns out, did not subsume it. We see the African patterns in American history, as Kano becomes a matrix of new journeys and, once again, the center of the world.

69

1. The artist has said that she is interested in exploring the ways that particular tools and technologies may "serve as metaphors for power dynamics." This description has been repeatedly cited in curatorial statements and exhibition-related documentation and by Tuggar in her published writing. See, most recently, Fatimah Tuggar, "Methods, Making, and West African Influences in the Work of Fatimah Tuggar," in *African Arts* 50, no. 4 (Winter 2017): 13.

2. See Alondra Nelson, "Future Texts," *Social Text* 20, no. 2 (Summer 2002): 1–15. See also Elizabeth Hamilton, "Analog Girls in a Digital World: Fatimah Tuggar's Afrofuturist Intervention in the Politics of 'Traditional' African Art," *Nka: Journal of Contemporary African Art* 33 (Fall 2013): 70–79. Note that more than 10 years separate Nelson's from Hamilton's articles, underscoring the staying power of the Afrofuturist label.

3. For a critical reevaluation of Afrofuturism that emphasizes, among other things, its power to deflect certain types of political analysis and that helpfully points out the limitations of its American deployments (as distinct from its deployments by artists and cultural producers living on the African continent or by those living in Europe), see Kodwo Eshun, "Further Considerations on Afrofuturism," in *The New Centennial Review* 3, no. 2 (Summer 2003): 287–302. Regarding the artist's own reservations about this term, see Tuggar, "Methods, Making, and West African Influences in the Work of Fatimah Tuggar," 13.

4. "CAVE" is a recursive acronym that refers to a range of different "cave automatic virtual environments" that provide the user with an immersive VR experience. The CAVE for which *Desired Dwellings* was designed and in which I was lucky enough to view/use the work, in Duke University's DiVE (Duke Immersive Virtual Environment), utilizes projection on six surfaces (four walls plus floor and ceiling). I am grateful to David Zielinski, of the DiVE, as well as to Amanda Gilvin and Fatimah Tuggar for facilitating my viewing of *Desired Dwellings* in December 2018.

5. The artist writes of her desire to alter "the social, the structural, and the visceral" within and among different civilizations. Tuggar, "Methods, Making, and West African Influences in the Work of Fatimah Tuggar," 12. It is interesting to note that the concept of the "visceral" has become the focus of recent gender and queer theory, as exemplified by the double special issue of *GLQ*, edited by Kyla Wazana Tompkins, titled "On the Visceral." See "On the Visceral," *GLQ: A Journal of Lesbian and Gay Studies* 20, no. 4 (October 2014), and "On the Visceral 2," *GLQ: A Journal of Lesbian and Gay Studies* 21, no. 1 (January 2015).

6. Nicole R. Fleetwood, "Visible Seams: Gender, Race, Technology, and the Media Art of Fatimah Tuggar," in *Signs: Journal of Women in Culture and Society* 30, no. 1 (2004), 1431. Fleetwood borrows the concept of "suture" from feminist and psychoanalytic film theory. Following the artist's own lead, however, she complicates these theories' (and the contemporary art world's) presumption of whiteness by calling attention to the irreparable ruptures introduced, through the visible presence of the black female spectator in the artwork, in the dominant representational frameworks and image ecologies. Ultimately, Fleetwood connects this rupture to the equally radical rupture produced in Tuggar's work through its inclusion of the hand of the "black, non-Western cultural producer" (Fleetwood, "Visible Seams," 1431). I will return to this powerful concept, theorized by Fleetwood, later in this essay.

7. Delinda Collier, "Obsolescing Analog Africa: A Re-reading of the 'Digital' in Digital Art," *Critical Interventions: Journal of African Art History and Visual Culture* 8 (2014): 279–289; Hamilton, "Analog Girls in a Digital World," 70–79; Yates McKee, "The Politics of the Plane: On Fatimah Tuggar's *Working Woman*," *Visual Anthropology* 19, no. 5 (October–December 2006): 417–422; Yates McKee, "Suspicious Packages," *October* 117 (Summer 2006): 99–121; and Alondra Nelson, "Future Texts," 1–15.

8. I take this description from an e-portfolio of documentation images that was provided to me by the artist.

9. The artist has also mentioned the threats posed by Boko Haram to travelers to the region, thereby impacting the dye wells by further reducing the number of clients willing and able to travel to the region.

10. Tuggar, "Deep Blue Wells: Production Notes" (August 2018), p. 1 and personal communication with the author, August 18, 2018.

PLATES

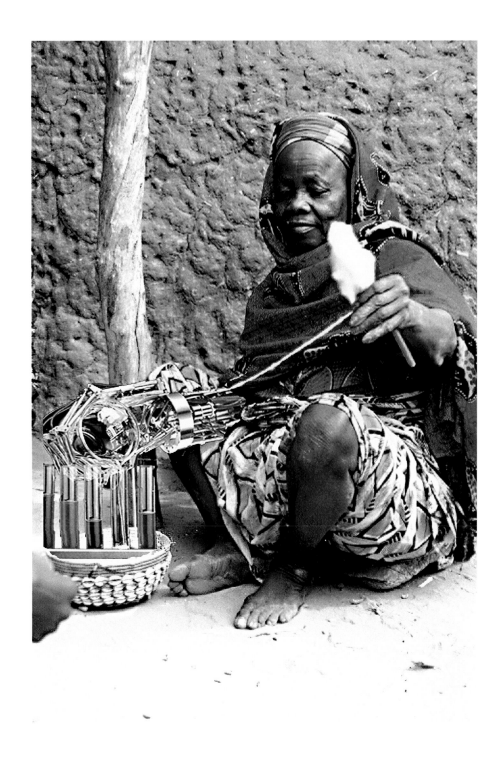

The Spinner and the Spindle, 1995
Computer montage (inkjet on vinyl)
20 × 30 in. (50 × 76 cm)

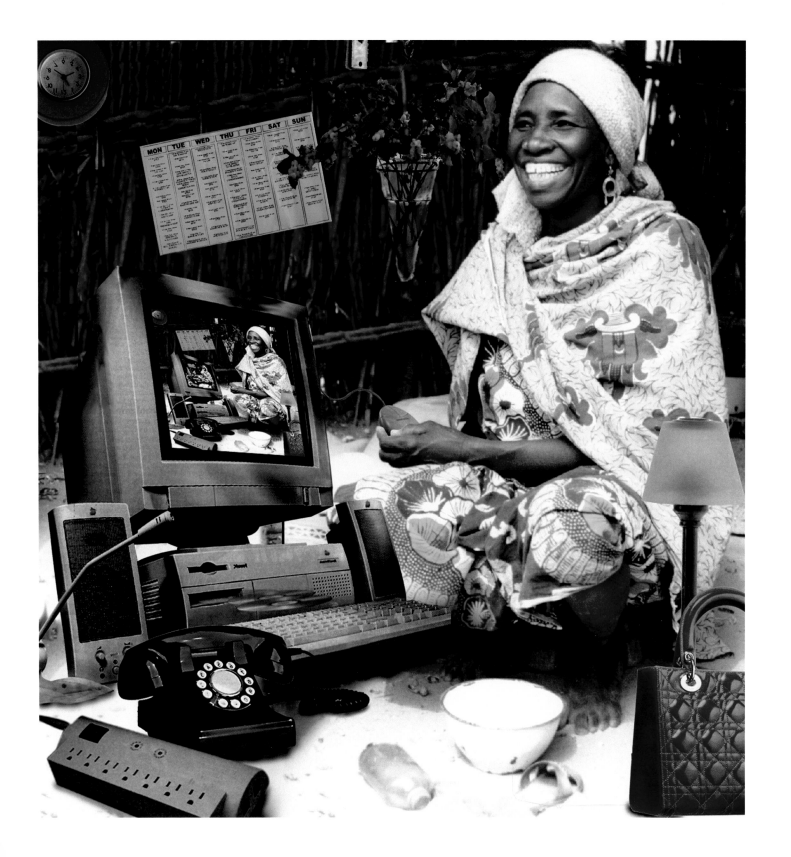

LEFT
Working Woman, 1997
Computer montage (inkjet on vinyl)
50 × 48 in. (128 × 121 cm)

OPPOSITE
Sibling Rivalry, 1995
Computer montage (inkjet on vinyl)
20 × 30 in. (50 × 76 cm)

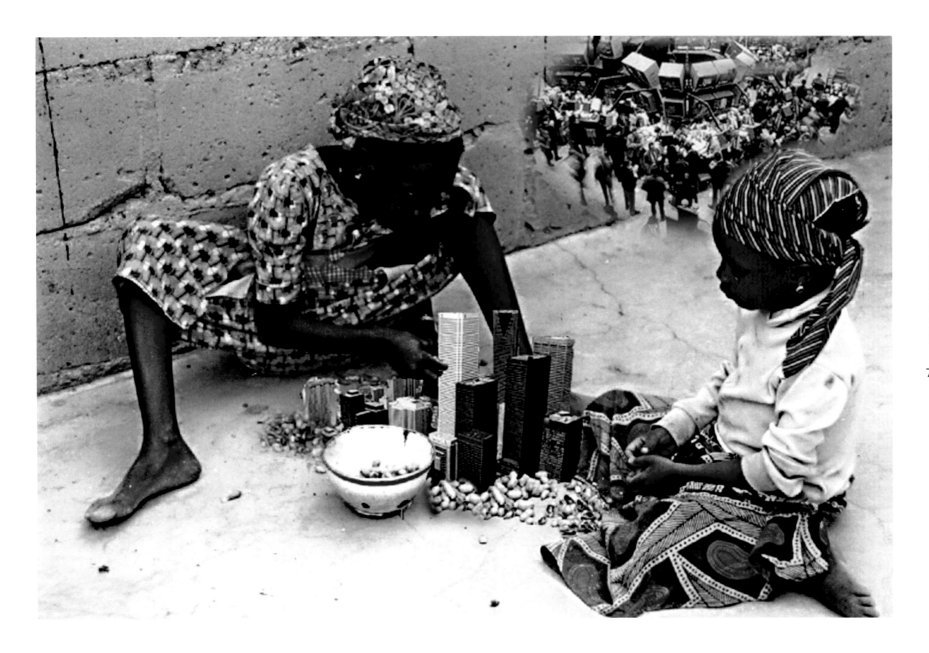

Shaking Buildings, 1996
Computer montage (inkjet on vinyl)
20 × 23 in. (50 × 58 cm)

78

ABOVE
Pleasures, 1996
Computer montage (inkjet on vinyl)
20 × 30 in. (50 × 76 cm)

OPPOSITE
Untitled (Army), 1996
Computer montage (inkjet on vinyl)
36 × 48 in. (91 × 121 cm)

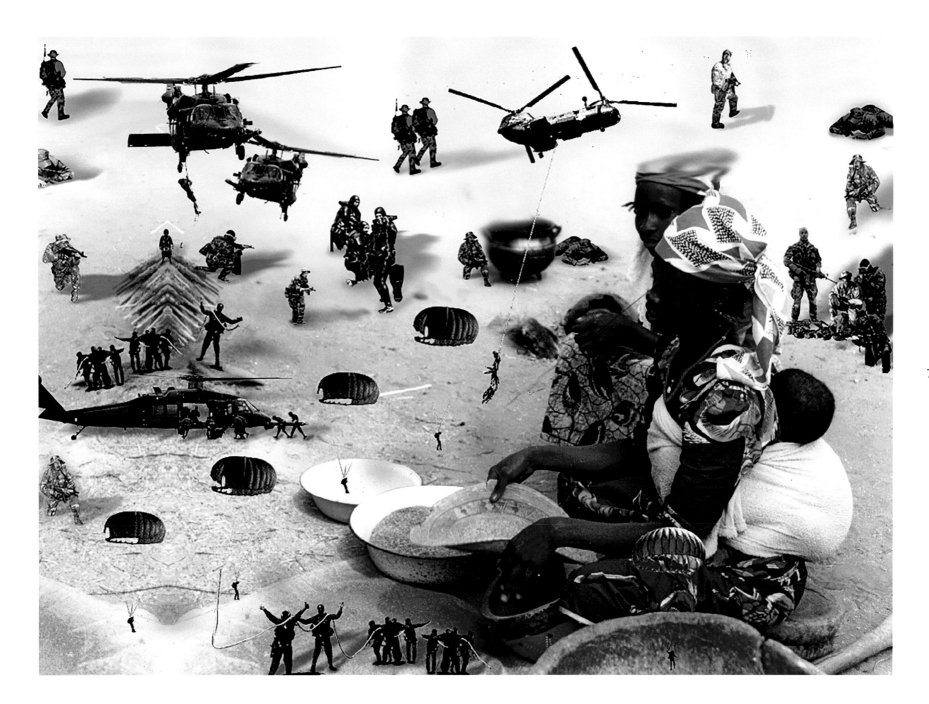

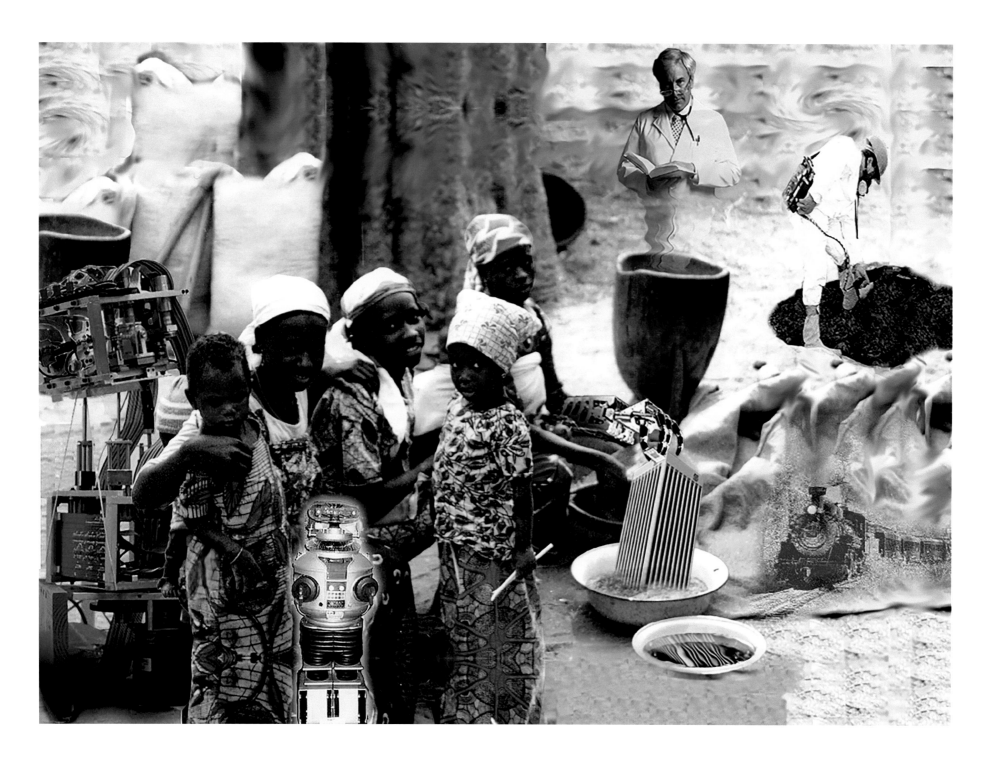

Village Spells, 1996
Computer montage (inkjet on vinyl)
35 × 49 in. (90 × 125 cm)

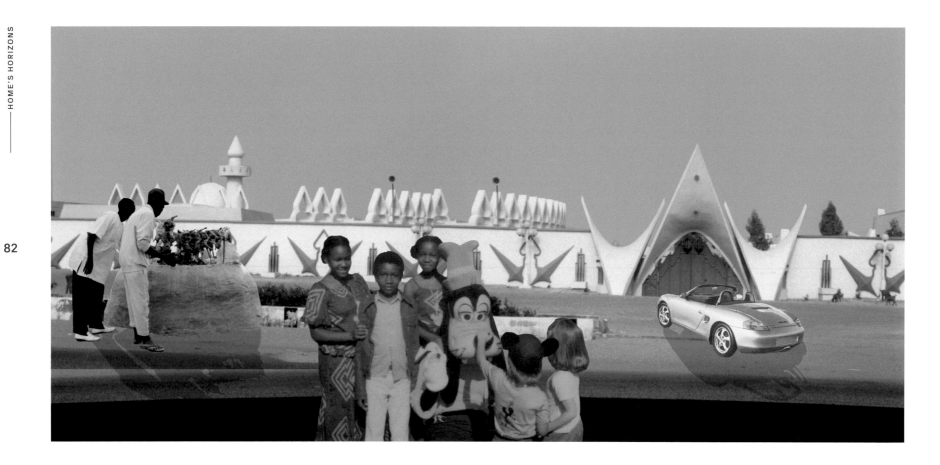

ABOVE AND DETAIL ON RIGHT
Family Compound, 2001
Computer montage (inkjet on vinyl)
44 × 96 in. (111 × 243 cm)

84

Suburbia, 1998
Computer montage (inkjet on vinyl)
48 × 96 in. (121 × 243 cm)

86

Untitled (Garden), 1997
Computer montage (inkjet on vinyl)
34 × 96 in. (85 × 243 cm)

88

Broom, 1996
Hay broom, electronic sound chip, speaker, power button
24 × 2 in. (70 × 5 cm)

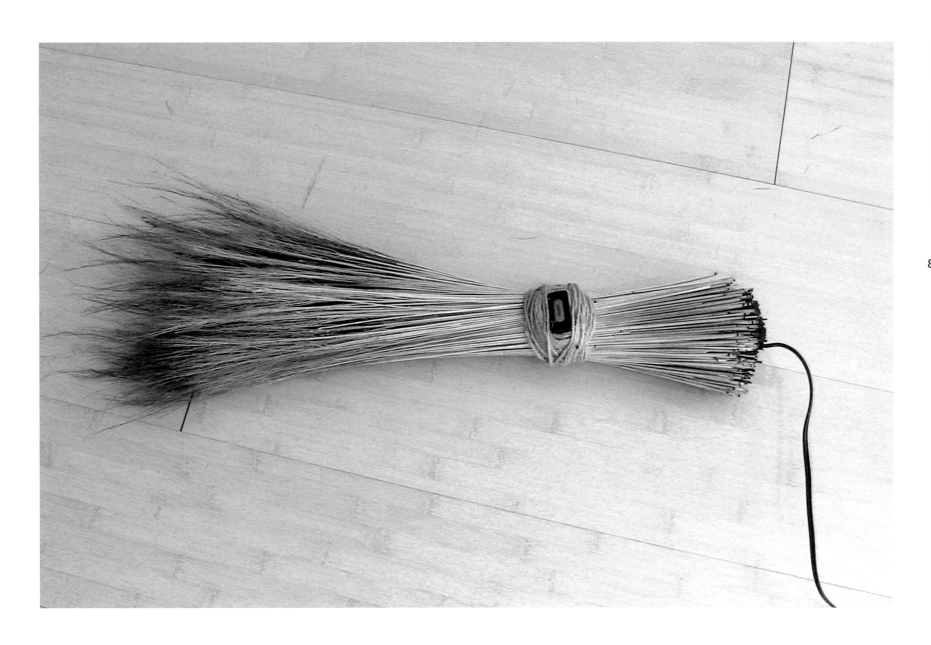

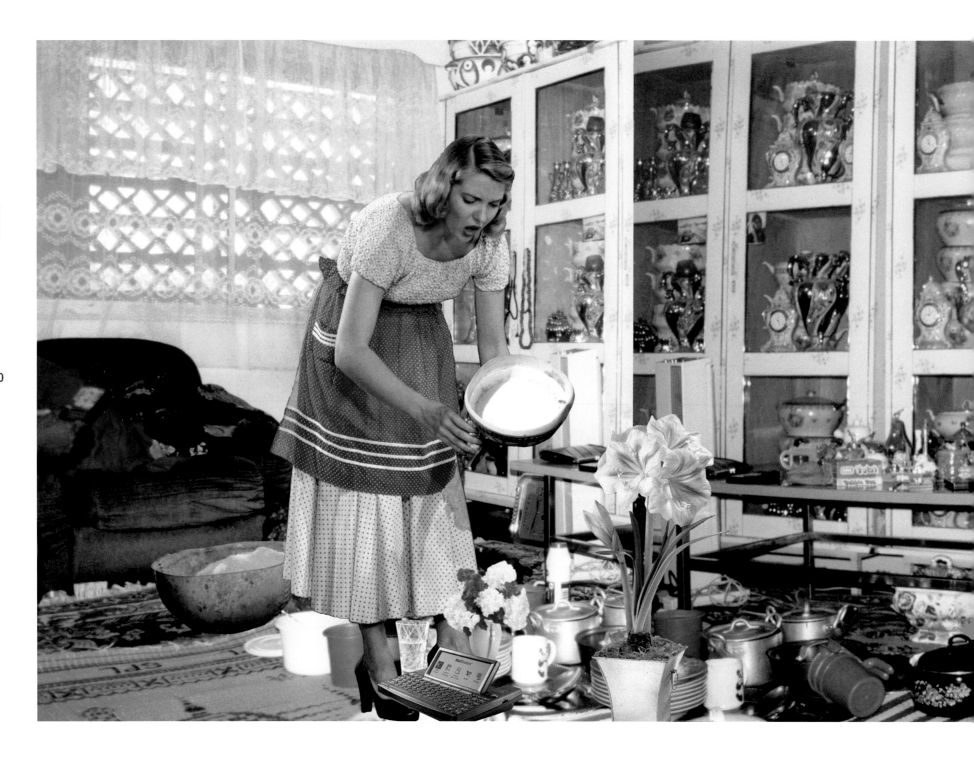

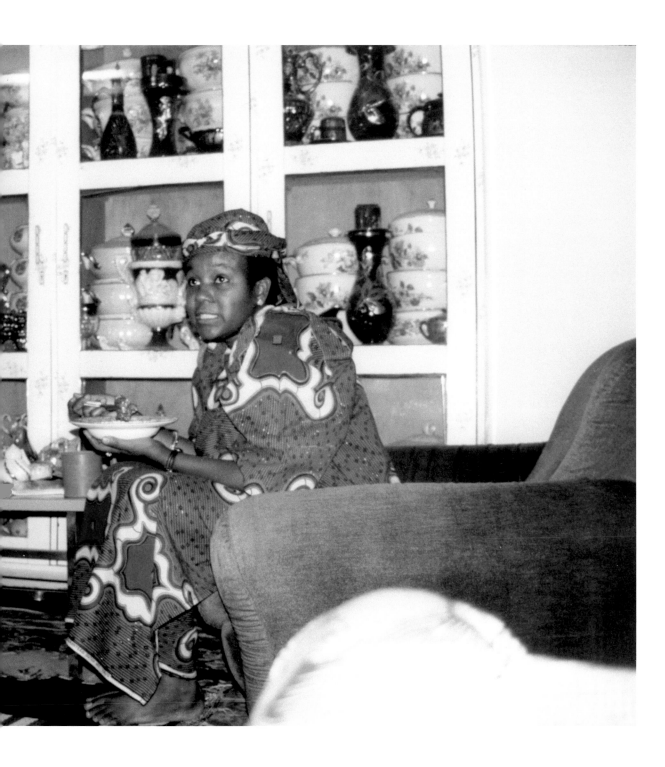

Lady and the Maid, 2000
Computer montage (inkjet on vinyl)
108 × 45 in. (274 × 115 cm)

92

RIGHT
Fai-Fain Gramophone, 2010
Record player, raffia disks,
speakers, labels, MP3 player
with music by Barmani Choge
53 × 32½ × 24 in.
(134.6 × 82.5 × 70 cm)
Davis Museum at Wellesley
College, Wellesley, MA
Museum purchase, The Dorothy
Johnston Towne (Class of 1923)
Fund 2019.944

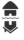

OPPOSITE
Detail, *Fai-Fain Gramophone*,
2010

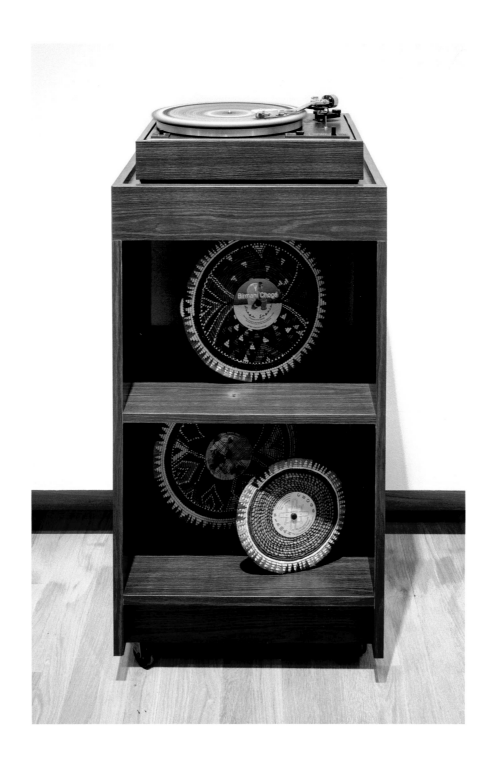

94

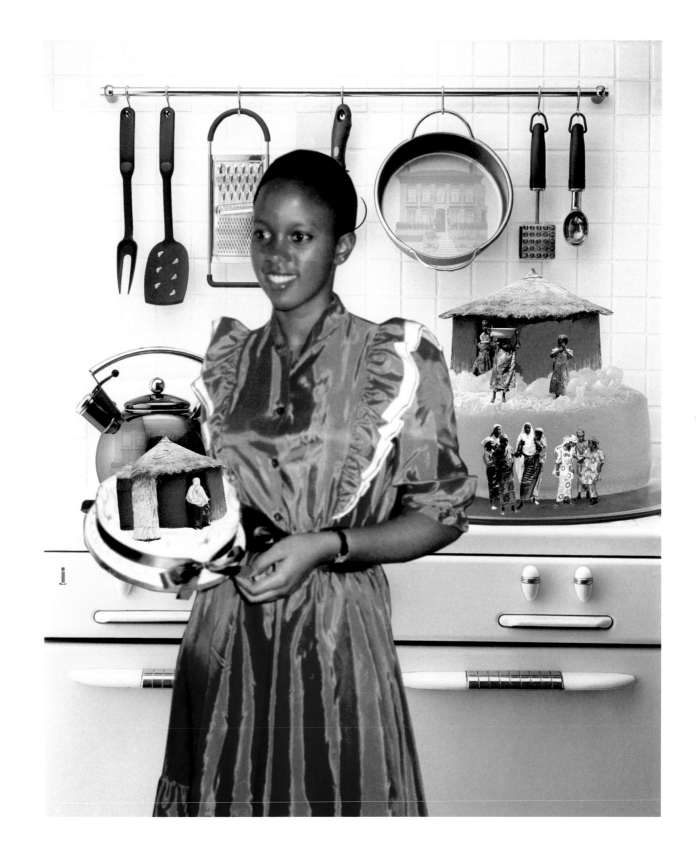

Cake People, 2001
Computer montage (inkjet on vinyl)
48 × 58 in. (121 × 147 cm)

Twig Whisk, 1996
Electric mixer, bulugari (miniature traditional whisks)
6 × 4 × 12 in. (15 × 10 × 30 cm)
Private collection

98

Fan, 1996
Ceiling fan, traditional hand fans
36 × 36 in. (91.5 × 91.5 cm)

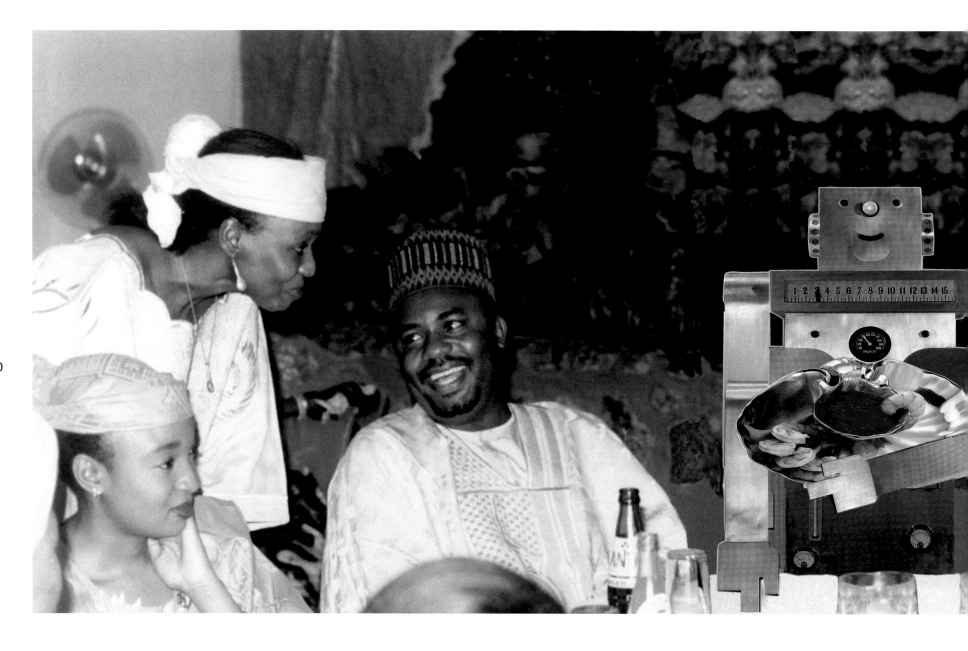

Robo Entertains, 2001
Computer montage (inkjet on vinyl)
48 × 140 in. (121 × 357 cm)

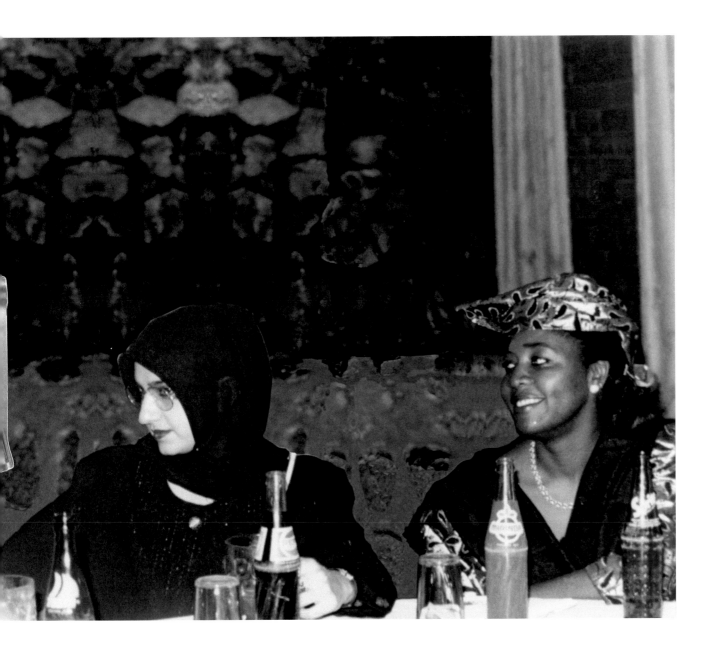

102

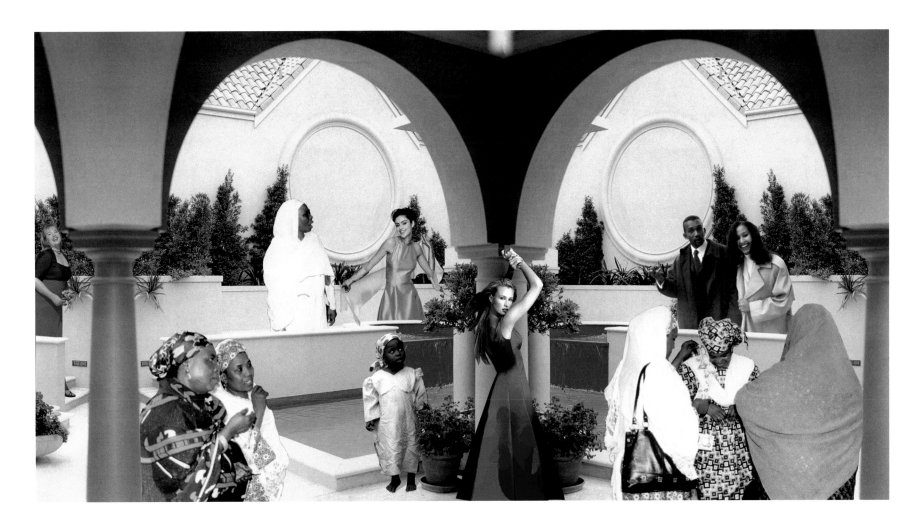

ABOVE AND DETAIL ON NEXT PAGES
Dancing by the Poolside, 2001
Computer montage (inkjet on vinyl)
144 × 50 in. (365 × 127 cm)

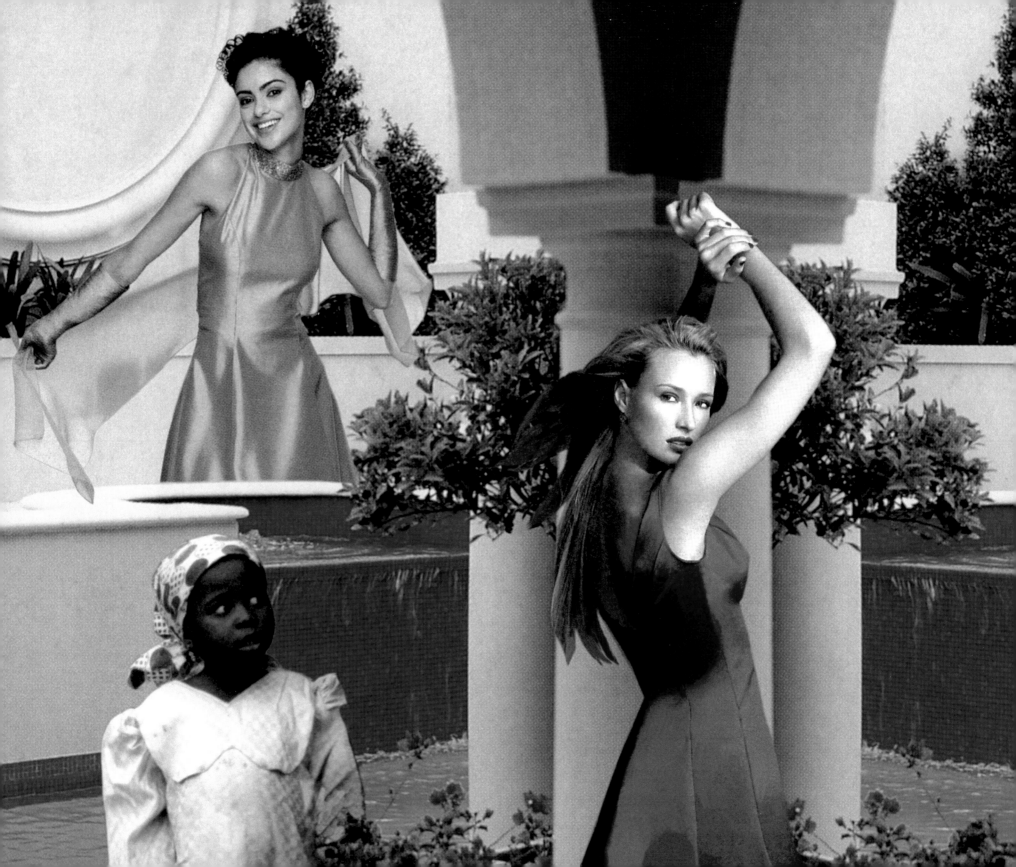

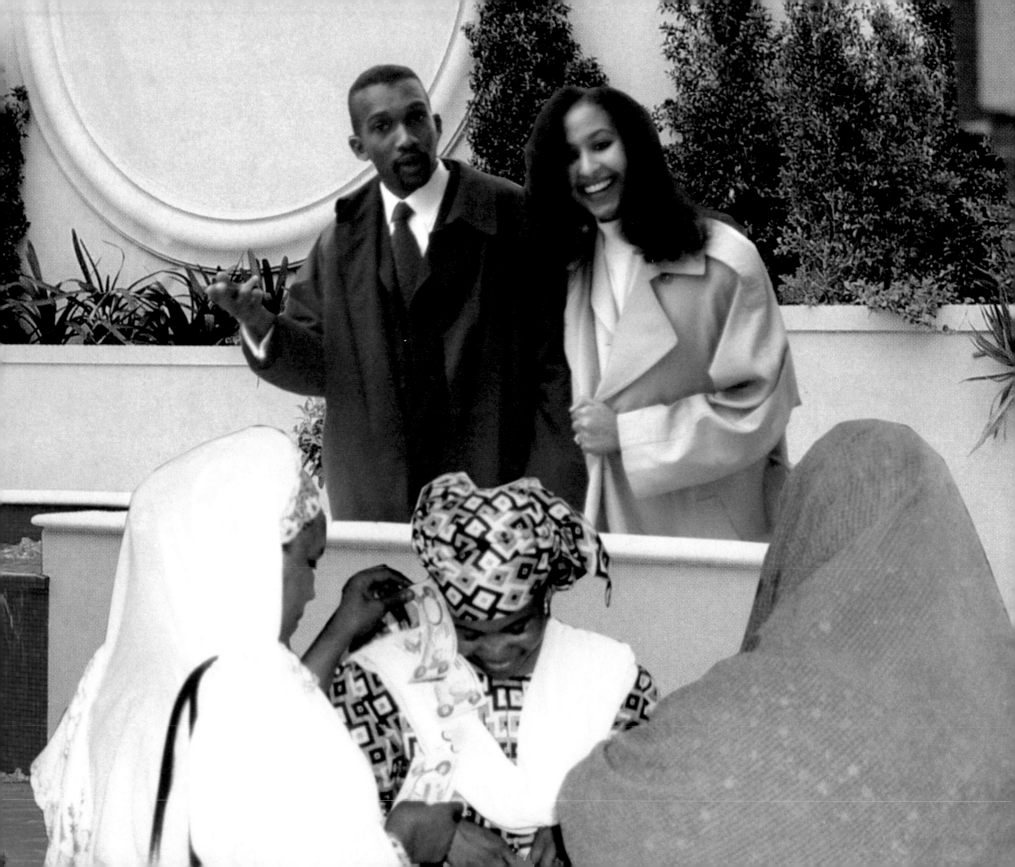

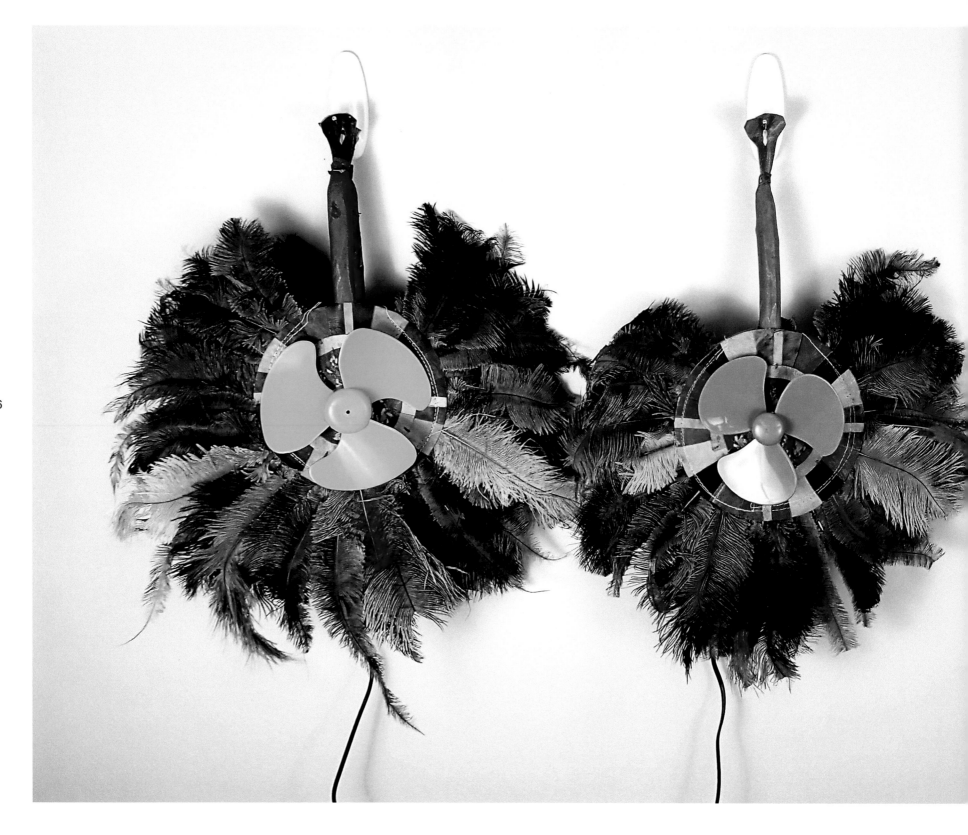

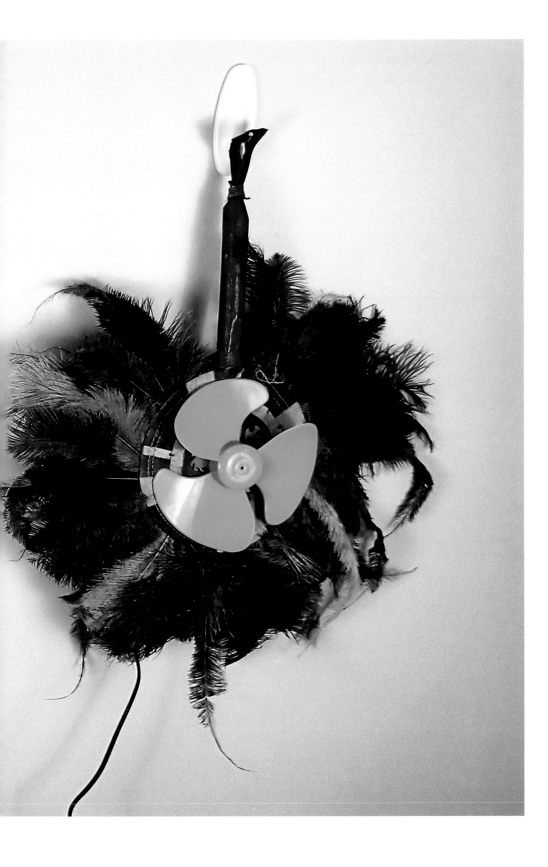

Fan-fan, 1999
Electric fans, traditional hand fans
Variable dimensions

108

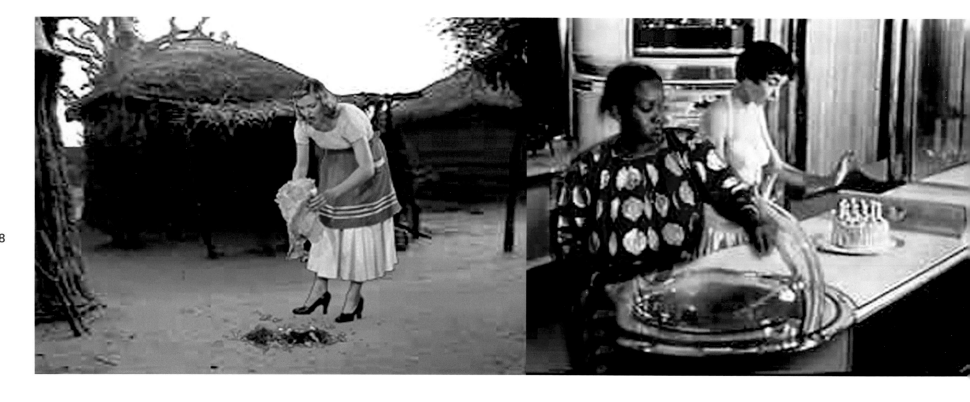

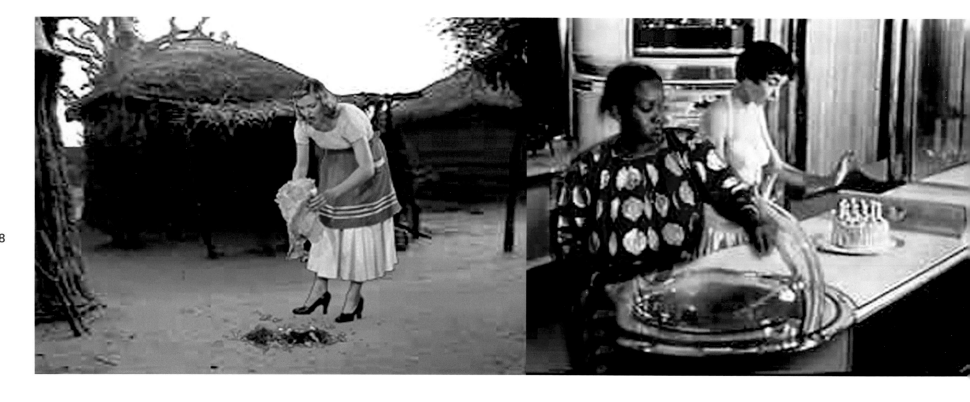 Stills from *Fusion Cuisine*, 2000
Video collage, 15 minutes,
40 seconds

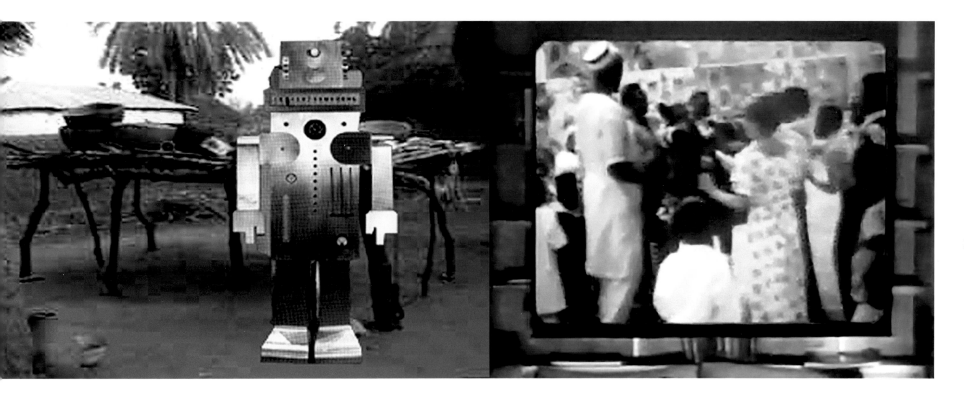

People Watching, 1997
Computer montage (inkjet on vinyl)
34 × 96 in. (86 × 243 cm)

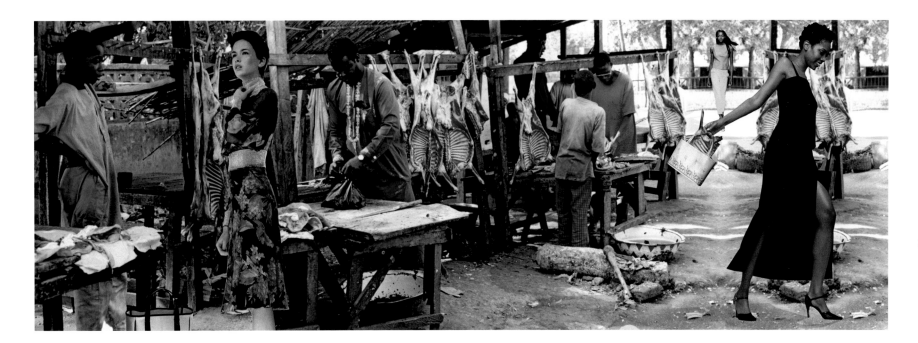

ABOVE AND DETAIL ON NEXT PAGES
At the Meat Market, 2000
Computer montage (inkjet on vinyl)
144 × 50 in. (365 × 127 cm)

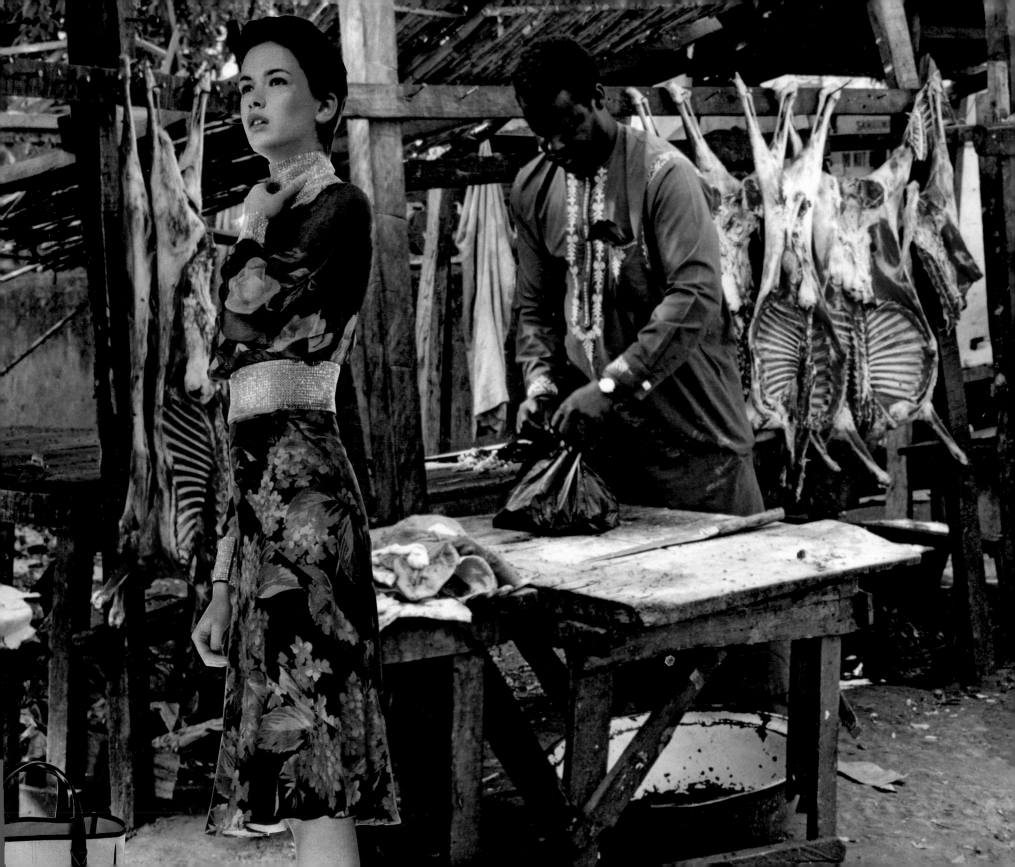

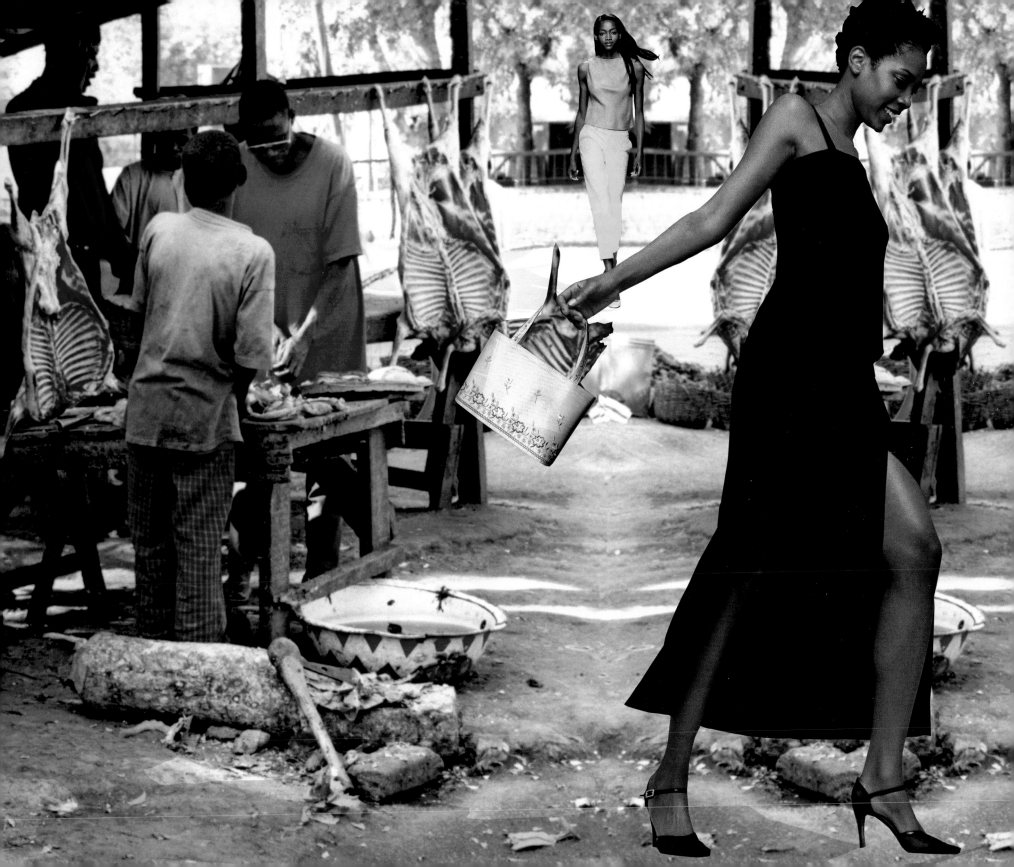

116

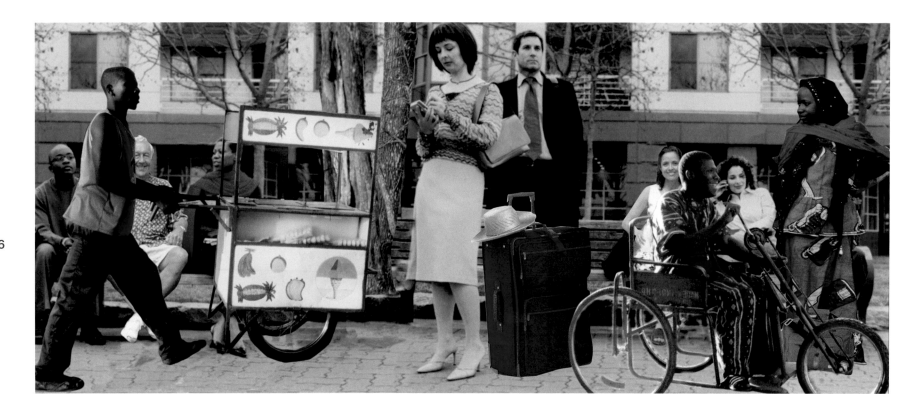

ABOVE AND DETAIL ON RIGHT
Nebulous Wait, 2005
Computer montage (inkjet on vinyl)
96 × 40 in. (243 × 101 cm)

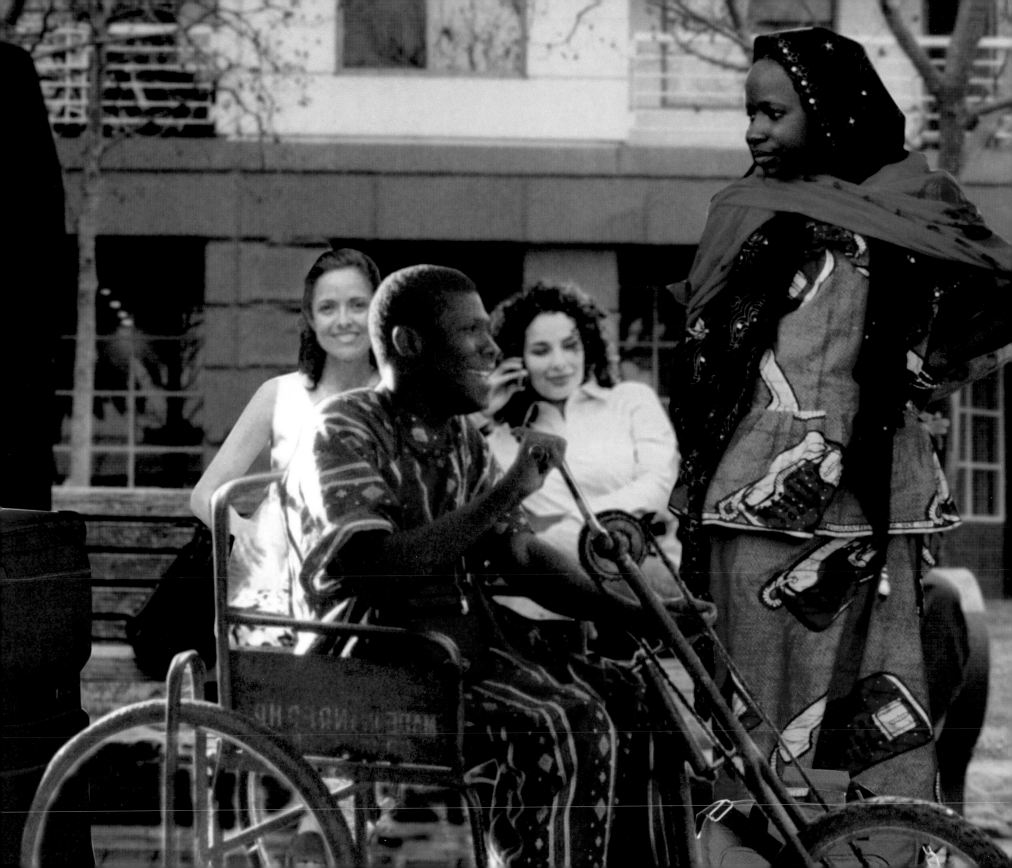

Town Square, 1996
Computer montage (inkjet on vinyl)
36 × 48 in. (91 × 121 cm)

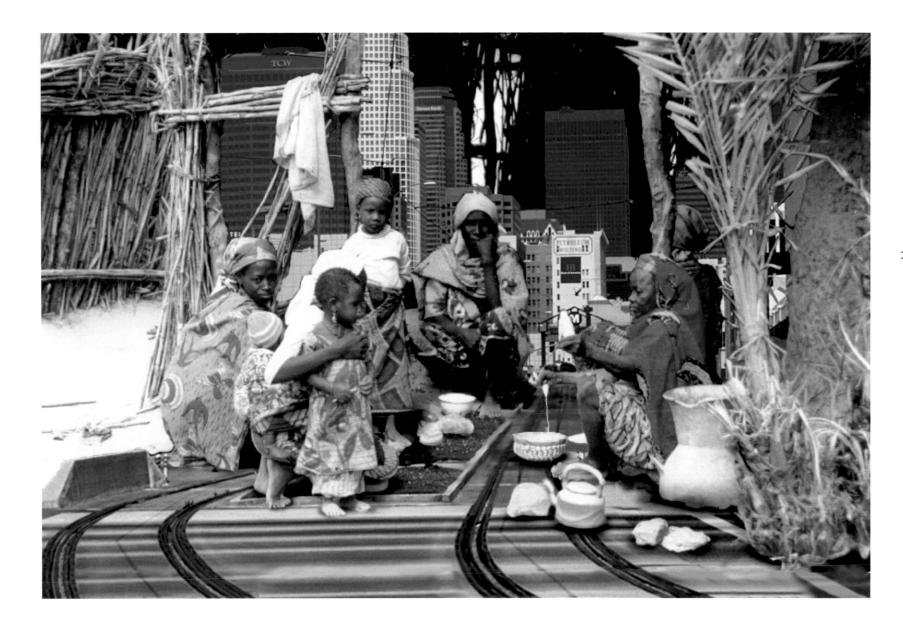

Voguish Vista, 2012
Computer montage (inkjet on vinyl)
72 × 50 in. (152 × 91 cm)

122

LEFT
Preparatory model for
Deep Blue Wells, 2018

ABOVE
Detail, Indigo fabric with Parliament House design,
from installation content in *Deep Blue Wells*, 2019

124

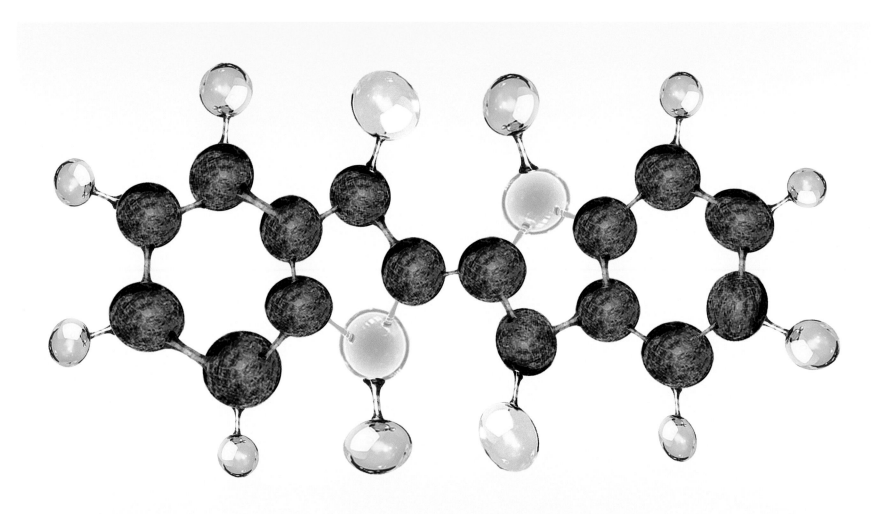

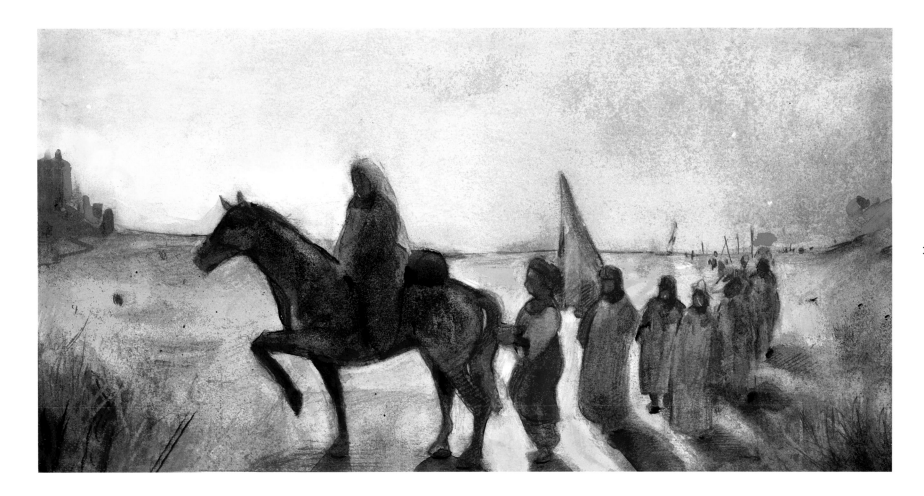

OPPOSITE
Sketch for 3-D animation of indigo molecule,
still from AR content in *Deep Blue Wells*, 2019

ABOVE
Daurama's Migration, still from AR content in
Deep Blue Wells, 2019

126

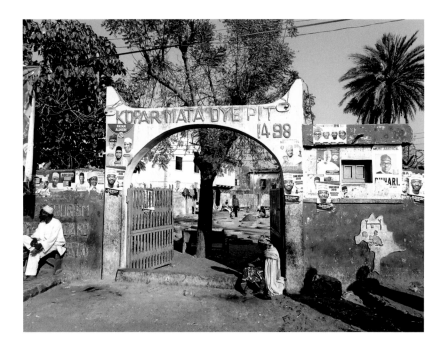

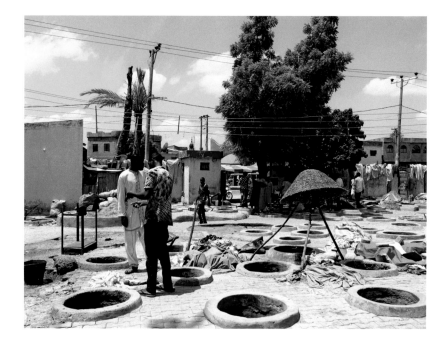

LEFT TO RIGHT
Gate to Kano tie-dye pits, still from
AR content in *Deep Blue Wells*, 2019

Dye pits in Kano, still from AR content
in *Deep Blue Wells*, 2019

Dan Asabe Uba dyeing a cloth, still from
AR content in *Deep Blue Wells*, 2019

Hafsat Abubakar and Jamila Hamisu
tying cloths to make designs, still from
AR content in *Deep Blue Wells*, 2019

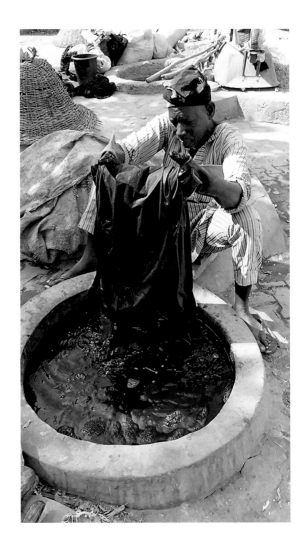

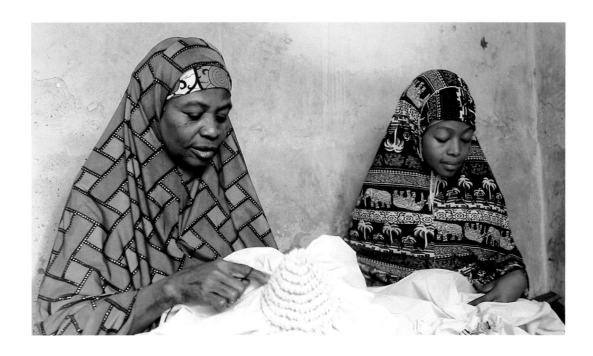

THE PLEASURES OF WORK
The Spinner and the Spindle, 1995
Computer montage (inkjet on vinyl)
20 × 30 in. (50 × 76 cm)
Collection of Alondra Nelson

Working Woman, 1997
Computer montage (inkjet on vinyl)
50 × 48 in. (128 × 121 cm)
Private collection

Sibling Rivalry, 1995
Computer montage (inkjet on vinyl)
20 × 30 in. (50 × 76 cm)

Shaking Buildings, 1996
Computer montage (inkjet on vinyl)
20 × 23 in. (50 × 58 cm)

Pleasures, 1996
Computer montage (inkjet on vinyl)
20 × 30 in. (50 × 76 cm)

Untitled (Army), 1996
Computer montage (inkjet on vinyl)
36 × 48 in. (91 × 121 cm)

Village Spells, 1996
Computer montage (inkjet on vinyl)
35 × 49 in. (90 × 125 cm)

DOMESTIC DREAMS
Family Compound, 2001
Computer montage (inkjet on vinyl)
44 × 96 in. (111 × 243 cm)

Suburbia, 1998
Computer montage (inkjet on vinyl)
48 × 96 in. (121 × 243 cm)

Untitled (Garden), 1997
Computer montage (inkjet on vinyl)
34 × 96 in. (85 × 243 cm)

Broom, 1996
Hay broom, electronic sound chip,
speaker, power button
24 × 2 in. (70 × 5 cm)

Lady and the Maid, 2000
Computer montage (inkjet on vinyl)
108 × 45 in. (274 × 115 cm)

Fai-Fain Gramophone, 2010
Record player, raffia disks, speakers,
labels, MP3 player with music by
Barmani Choge
53 × 32½ × 24 in.
(134.6 × 82.5 × 70 cm)
Davis Museum at Wellesley College,
Wellesley, MA
Museum purchase, The Dorothy
Johnston Towne (Class of 1923) Fund
2019.944

Cake People, 2001
Computer montage (inkjet on vinyl)
48 × 58 in. (121 × 147 cm)

Twig Whisk, 1996
Electric mixer, bulugari
(miniature traditional whisks)
6 × 4 × 12 in. (15 × 10 × 30 cm)
Private collection

AT THE PARTY
Fan, 1996
Ceiling fan, traditional hand fans
36 × 36 in. (91.5 × 91.5 cm)

Robo Entertains, 2001
Computer montage (inkjet on vinyl)
48 × 140 in. (121 × 357 cm)

Dancing by the Poolside, 2001
Computer montage (inkjet on vinyl)
144 × 50 in. (365 × 127 cm)

Fan-fan, 1999
Electric fans, traditional hand fans
Variable dimensions

FUSION CUISINE
Stills from *Fusion Cuisine*, 2000
Video collage, 15 minutes, 40 seconds
Technician: James Rattazzi
Intern: San Woo
Participants: Aishatu Usman, Amina
Mohammed Duku, Bintan Kwakwata,
Halima Usman, Hawa Abdullahi,
Yalwati Anyama, Villages of Tilde
and Ɗukul
Found footage from the Ephemeral
Film Archives
Produced by The Kitchen and
BintaZarah Studios

PEOPLE WATCHING
People Watching, 1997
Computer montage (inkjet on vinyl)
34 × 96 in. (86 × 243 cm)

At the Meat Market, 2000
Computer montage (inkjet on vinyl)
144 × 50 in. (365 × 127 cm)

Nebulous Wait, 2005
Computer montage (inkjet on vinyl)
96 × 40 in. (243 × 101 cm)

Town Square, 1996
Computer montage (inkjet on vinyl)
36 × 48 in. (91 × 121 cm)

Voguish Vista, 2012
Computer montage (inkjet on vinyl)
72 × 50 in. (152 × 91 cm)

DEEP BLUE WELLS
Preparatory model for *Deep Blue
Wells*, 2018
Credits for *Deep Blue Wells*:
Historical, Technical and Tie-dye
Educational Information:
Baballia Hamisu, Hafsat Abubakar,
Jamila Hamisu, Haruna Baffa
Kano AV Crew: Ali Hussani,
Jimoh Yusuf, and Mudassir̃ Ali
AR Technical Team: Colin Zelin,
Jesse Berdinka, Maura Hunter,
Adam Peled, and Zach Weiner
Exhibition Design: Mark A. Beeman
Resource Advice: Laura Blumenberg
Technical Support: Sarina Khan-Reddy
Technical Advice: Jordan Tynes and
Michael Lightsmith
Ceramics Production: Tommy Frank
Interns: André A. Melchor,
Caleb Putman, Elana Bridges,
Maddy Allan-Rahill, and Yanni Li
Kofar Mata Dye Pits
Belger Crane Yard Studios
BrickSimple

Detail, Indigo fabric with Parliament
House design, from installation
content in *Deep Blue Wells*, 2019

Sketch for 3-D animation of indigo
molecule, still from AR content in
Deep Blue Wells, 2019

Daurama's Migration, still from
AR content in *Deep Blue Wells*, 2019

Gate to Kano tie-dye pits, still from
AR content in *Deep Blue Wells*, 2019

Dye pits in Kano, still from AR content
in *Deep Blue Wells*, 2019

Ɗan Asabe Uba dyeing a cloth,
still from AR content in *Deep Blue
Wells*, 2019

Hafsat Abubakar and Jamila Hamisu
tying cloths to make designs, still from
AR content in *Deep Blue Wells*, 2019

130

FATIMAH TUGGAR

Multidisciplinary artist Fatimah Tuggar was born in Nigeria in 1967, and she was raised there and in the United Kingdom. She has studied, lived, and worked in the United States since the late 1980s. Her work uses technology as both medium and subject to serve as metaphors for power dynamics. She combines objects, images, and sounds from diverse cultures, geographies, and histories to comment on how media and technology diversely impact local and global realities. Tuggar's work seeks to enable the agency of the viewer/participant as implicated in the dynamics of making, subject, object, and experience; to which end she fosters interactivity, even when using soi-disant "traditional and non-technological" materials. Her position is that all human making is technological and collaborative. Tuggar's work has been exhibited in over twenty-five countries on five continents at venues such as the Museum of Modern Art (New York, New York), Museum Kunstpalast (Dusseldorf, Germany), Centre Georges Pompidou (Paris, France), Biennial of Graphic Art (Ljubljana, Slovenia), Moscow Biennale (Russia), V Salon CANTV Jovenes (Venezuela), Istanbul Biennial (Turkey), Kwangju Biennale (South Korea), Bamako Encounters, Biennale of African Photography (Mali), and second Johannesburg Biennale (South Africa). She has been a recipient of many awards and commissions, including fellowships from the John Simon Guggenheim Foundation, John Hope Franklin Humanities Institute at Duke University, and Civitella Ranieri Foundation. She has produced commissioned works for the Museum of Modern Art (New York, New York), Bronx Museum of the Arts, (The Bronx, New York), Nordic Institute of Contemporary Art (Copenhagen, Denmark) and the Spencer Museum of Art at the University of Kansas (Lawrence, Kansas).

——EDUCATION ——SELECTED SOLO EXHIBITIONS

1995–1996
Whitney Museum of
American Art, New York,
New York
Independent Study Program

1992–1995
Yale University, New Haven,
Connecticut
MFA in Sculpture

1992
Skowhegan School of
Painting and Sculpture,
Skowhegan, Maine
Summer Program

1987–1992
Kansas City Art Institute,
Kansas City, Missouri
Bachelor of Fine Arts

1984–1986
Blackheath School of Art,
London, UK
Foundation Studies

2013
*Fatimah Tuggar: In/Visible
Seams*, University Museum
at the University of Delaware,
Newark, Delaware.

2012
Fatimah Tuggar, Institute
for Women and Art, Mary
Hana Women Artists Series
Galleries, Rutgers University,
New Brunswick, New Jersey.

2011
*Dream Team, Works from
1995–2011*, GreenHill Center
for North Carolina Art,
Greensboro, North Carolina.

2010
One Blithe Day, Link Media
Wall, Perkins Library,
Duke University, Durham,
North Carolina.

2009
*Tell Me Again: A Concise
Retrospective*, John Hope
Franklin Humanities Center,
Duke University, Durham,
North Carolina.

*Desired Dwellings: Project for
an Immersive Environment*,
Duke Immersive Virtual
Environment, Duke University,
Durham, North Carolina.

2005
*Meditation on Vacation
and Conveyance*, Rencontres
de Bamako, Biennale
Africaine de la Photographie,
Bamako, Mali.

2002
Changing Space, Art
Production Fund, New York,
New York.

Video Room, Art and Public,
Geneva, Switzerland.

The Avram Gallery,
Southampton College of
Long Island University,
Southampton, New York.

2001
Celebrations, Galeria Joao
Graça, Lisbon, Portugal.

2000
At the Water Tap, Greene
Naftali Gallery, New York,
New York.

Fusion Cuisine, Le Musée
Chateau, Annecy, France.

Fusion Cuisine and *Tell Me
Again*, The Kitchen, New York,
New York.

Fatimah Tuggar, Art and
Public, Geneva, Switzerland.

1998
Village Spells, Web-based
project, plexus.org, New York,
New York.

1992
Revolving Room,
The Founders Gallery,
Kansas City, Missouri.

Between Space and Light,
Leedy-Volkus Art Center,
Kansas City, Missouri.

2019

Charlotte Street Awards Exhibition, Kemper Museum of Contemporary Art, Kansas City, Missouri.

Knowledge, The Spencer Museum of Art, The University of Kansas, Lawrence, Kansas.

2018

Flow of Forms / Forms of Flow (traveling exhibition), Museum am Rothenbaum, Hamburg, Germany.

2017

Flow of Forms / Forms of Flow (traveling exhibition), Kunstraum, München, Germany.

2015

Appropriation Art: Finding Meaning in Found-Image Collage, The Bascom: A Center for the Visual Arts, Highlands, North Carolina.

2013

Nowhere Differentiable, Simons Center for Geometry and Physics, Stony Brook University, Stony Brook, New York.

2012

The Record (traveling exhibition), Henry Art Gallery, Seattle, Washington.

The Record (traveling exhibition), Miami Art Museum, Miami, Florida.

Harlem Postcards, The Studio Museum in Harlem, New York, New York.

Young, Fabulous, and Female, The Root Magazine, New York, New York.

2011

The Record (traveling exhibition), Institute of Contemporary Art, Boston, Massachusetts.

H&R Block Artspace, Kansas City Art Institute, Kansas City, Missouri.

On Screen: Global Intimacy (traveling exhibition), Bermuda National Gallery, Hamilton, Bermuda.

2010

The Record (traveling exhibition), Nasher Museum of Art at Duke University, Durham, North Carolina.

Festival Mondial des Arts Nègres, Dakar, Senegal.

2009

On Screen: Global Intimacy (traveling exhibition), University of Illinois at Urbana-Champaign, Illinois.

2008

Street Art, Street Life, Bronx Museum of the Arts, The Bronx, New York.

By Invitation Only 2, Invited by Pamela Auchincloss, Kinz, Tillou, + Feigen Gallery, New York, New York.

A New Cosmopolitanism, Main Art Gallery, University of California at Fullerton, California.

2007

Late Empire, Roebling Hall, New York, New York.

Video Atlas Americas, Oi Futuro, Rio de Janeiro, Brazil.

Kiss Kiss Bang Bang, Museo de Bellas Artes de Bilbao, Bilbao, Spain.

Moving People: Africa-Asia Interface on Migration/ Refugee/Exile/Diaspora, World Social Forum, Nairobi, Kenya.

Interstellar Low Ways, Hyde Park Art Center, Chicago, Illinois.

2006

Africa Remix (traveling exhibition), Moderna Museet, Stockholm, Sweden.

Africa Remix (traveling exhibition), Mori Art Museum, Tokyo, Japan.

Rethinking Nordic Colonialism, Nordic Institute for Contemporary Art (NIFCA), Rovaniemi, Finland.

2005

Dialectics of Hope, Moscow Biennale of Contemporary Art, Moscow, Russia.

Africa Remix (traveling exhibition), Hayward Gallery, London, England.

Africa Remix (traveling exhibition), Centre Georges Pompidou, Paris, France.

Staged Realities (traveling exhibition), BildMuseet, Umeå, Sweden.

World Views, Rose-Hulman Institute of Technology, Terre Haute, Indiana.

2004

Paraent, Kunsthalle Krems, Krems, Austria.

International Geographic, Galerie SAW Gallery, Ottawa, Ontario, Canada.

Open House, Brooklyn Museum of Art, Brooklyn, New York.

Staged Realities (traveling exhibition), Michael Stevenson Contemporary, Cape Town, South Africa.

Africa Remix (traveling exhibition), Museum Kunstpalast, Dusseldorf, Germany.

10 Commandments, Deutsches Hygiene-Museum, Dresden, Germany.

2003

Rencontres de Bamako: Biennale Africaine de la Photographie, Bamako, Mali.

Transferts, Palais des Beaux-Arts, Brussels, Belgium.

UNESCO Salutes Women Artists, UNESCO, Paris, France.

Espai d'ar contemporani de Castelló, Castelló, Spain.

2002

No Border, Museo d'Arte della città di Ravenna, Ravenna, Italy.

The Field's Edge, Contemporary Art Museum, University of South Florida, Tampa, Florida.

City and Urbanity, Busan Biennale, Busan, Korea.

Tempo, Museum of Modern Art, New York, New York.

Empire/State: Artists Engaging Globalization, Curatorial Studies Program, Whitney Museum of American Art, New York, New York.

V Salón CANTV Jovenes con FIA, Caracas, Venezuela.

Flash, City Gallery East, Atlanta, Georgia.

Fusion Cuisine, Deste Foundation, Athens, Greece.

VideoROM, Galeria Giancarla Zanutti, Milan, Italy.

God's Transistor Radio: IbridAAfricA, Museo Nazionale Preistorico Etnografico Luigi Pigorini, Rome, Italy.

Africaine: Candice Breitz, Wangechi Mutu, Tracey Rose, and Fatimah Tuggar, The Studio Museum in Harlem, New York, New York.

2001

Looking With/Out, East Wing Collection No. 05, London, England.

Mujeres que Hablan de Mujeres (Women Talk About Women), Centro de Fotografía, Islas Canarias, Spain.

A Work in Progress, New Museum of Contemporary Art, New York, New York.

Poetics and Power, Cleveland Center for Contemporary Art, Cleveland, Ohio.

Crossing the Line, Queens Museum of Art, Queens, New York.

Print World, Biennial of Graphic Art, Ljubljana, Slovenia.

The New World: Vices and Virtues, Bienal de Valencia, Valencia, Spain.

Bienal da Maia, Porto, Portugal.

Post Production, Arte Continua, San Gimignano, Italy.

2000

Pitch - Mutating Turntables, Argosfestival 2002, Argos, Brussels.

Tell It Like It Is, Volker Diehl Gallery, Berlin, Germany.

Photography Now, Contemporary Arts Center, New Orleans, Louisiana.

EuroAfrica, Kwangju Biennale Korea 2000, Kwangju, Korea.

Translations, Center for Curatorial Studies, Bard College, Annandale-on-Hudson, New York.

Veronica's Revenge, Museum of Contemporary Art, Sydney, Australia.

1999

The Passion and the Wave, 6th International Istanbul Biennial, Istanbul, Turkey.

Beyond Technology, Brooklyn Museum of Art, Brooklyn, New York.

Domestic Pleasures, Galerie Lelong, New York, New York.

Lost and Found, Audiello Fine Arts, New York, New York.

Generation Z, P.S. 1 Institute for Contemporary Art, Long Island City, New York.

Alternative: Alternative, Roebling Hall, Brooklyn, New York.

No Place Rather Than Here, 303 Gallery, New York, New York.

Alter Body, Galerie Lelong, New York, New York.

Space Ship Earth, Art in General, New York, New York.

1998
Keeping Track of the Jones's, New Museum of Contemporary Art, New York, New York.

Esperanto '98, Jack Tilton Gallery, New York, New York.

1997
Life's Little Necessities, The Second Johannesburg Biennale, Capetown, South Africa.

Rising Tides, Rush Arts, New York, New York.

1996
Interplace Access, Via Farini Gallery, Milano, Italy.

Act/Language: Power and Display, Institute for Research on the African Diaspora in the Americas and the Caribbean, City University, New York, New York.

Substituting Rasquachismo for Mimesis, Spot Gallery, New York, New York.

1995
City Flowers of the World, Galerie Die Werstatt, Copenhagen, Denmark.

1994
Black and Greenberg Gallery, New York, New York.

2019
Guggenheim Fellowship, New York, New York.

Charlotte Street Visual Artist Award, Kansas City, Missouri.

2018
Commission for Knowledges Exhibition, The Spencer Museum of Art, Lawrence, Kansas.

2012
Commission for *Harlem Postcards*, Studio Museum in Harlem, New York, New York.

2011
Commission for *Transient Transfer Greensboro*, GreenHill Center for North Carolina Art, Greensboro, North Carolina.

2008
A.W. Mellon Research Fellowship, John Hope Franklin Humanities Institute, Duke University, Durham, North Carolina.

Special Commission, Bronx Museum of the Arts, The Bronx, New York, New York.

In the Public Realm, Public Art Fund, New York, New York.

2006
Production Grant, Nordic Institute of Contemporary Art, Copenhagen, Denmark.

2003
Prix Spécial du Jury, Rencontres de Bamako, Biennale Africaine de la Photographie, Bamako, Mali.

2002
Immigrant Artist's Grant, New York Association for New Americans, Inc., New York, New York.

In Space (Web Art) Grant, Art Production Fund, New York, New York.

The Young with FIA Award, V Salon CANTV Jovenes, Caracas, Venezuela.

Change Grant, Change, Inc., Captiva, Florida.

2001
Civitella Ranieri Fellowship, Civitella Ranieri, Umbertide, Umbria, Italy.

2000
Artist Production Residency, The Kitchen, New York, New York.

Wheeler Foundation Grant, The Wheeler Foundation, Brooklyn, New York.

Techno-Oboro Residency, Oboro Arts Center, Montreal, Canada.

1999
Grant from the Fund for United States Artists at International Festivals and Exhibitions, Arts International.

Emerging Artist Grant, The Rema Mann Hort Foundation, New York, New York.

135

PUBLIC COLLECTIONS

CH

Art and Public Collection, Geneva

GER

Diehl Vorderwuelbecke Collection, Berlin

PT

Galeria Joao Graça Collection, Lisbon

US

John Hope Franklin Humanities Institute, Duke University, Durham, North Carolina

The Wadsworth Atheneum Museum, Hartford, Connecticut

The Progressive Art Collection, Mayfield Village, Ohio

Altoids, the Curiously Strong Collection, New Museum of Contemporary Art, New York, New York

Columbia University, School of Social Work, New York, New York

The Kitchen, New York, New York

RX Art Collection, New York, New York

Studio Museum in Harlem, New York, New York

Weil, Gotshal and Manges Collection, New York, New York

University Museums, University of Delaware, Newark, Delaware

University of Southern Florida at Tampa, Tampa, Florida

The Network for Women's Services, Washington, District of Columbia

The Wadsworth Atheneum Museum of Art, Hartford, Connecticut

Davis Museum at Wellesley College, Wellesley, Massachusetts

SELECTED BIBLIOGRAPHY

2013

Tuggar, Fatimah, "Semiotics: A Visual Exploration of Signifiers, Meaning, Processes, and Materials," in *72 Assignments: The Foundation Course in Art and Design Today, A Practical Source Book for Teachers, Students, and Anyone Curious to Try*, Chloe Briggs, ed. Paris: Paris College of Art Press.

2012

Brodsky, Judith, and Ferris Olin, eds. *The Fertile Crescent: Gender, Art, and Society*. New Brunswick, NJ: Rutgers University Institute for Women and Art.

2011

Fleetwood, Nicole R. *Troubling Vision: Performance, Visuality, and Blackness*. Chicago, IL: The University of Chicago Press.

2010

Schoonmaker, Trevor, ed. *The Record: Contemporary Art and Vinyl*. Durham, NC: Nasher Museum of Art at Duke University and Duke University Press.

Williams, Carla and Deborah Willis. *Black Venus 2010: They Called Her "Hottentot."* Philadelphia, PA: Temple University Press.

2009

Du Preez, Amanda. *Gendered Bodies and New Technologies: Rethinking Embodiment in a Cyber-Era*. Newcastle upon Tyne, UK: Cambridge Scholars Publishing.

2008

Chaney, Rachel and Michel Oren. *A New Cosmopolitanism. Preeminence of Place in Contemporary Art*. Fullerton, CA: CSU Fullerton Main Art Gallery.

Herkenhoff, Paulo. *Atlas Américas*, Rio de Janeiro: Contra Capa Livraria.

2007

Tiberini, Stefania, ed. *Black Ink*. Rome: University La Sapienza Press.

2005

Bourriaud, Nicolas, Jeanine Herman, and Caroline Schneider. *Postproduction: Culture as Screenplay: How Art Reprograms the World*. New York, NY: Lukas and Sternberg.

Brielmaier, Isolde. *Vitamin Ph: New Perspectives in Photography*. London: Phaidon Press.

2003

Spector, Nancy. "Contemporary Art in Culture, Fatimah Tuggar" in *Cream 3: Contemporary Art in Culture: 10 Curators, 10 Contemporary Artists, 10 Source Artists*, Carolyn Christov-Bakargiev, ed. London: Phaidon Press.

2002

Tuggar, Fatimah. "Ohne Titel," in *Der Hund is Für Die Hyä. Neine Kolanuss: Zeitgenössische Kunst und Kultur aus Afrika*, Clara Himmelheber, ed. Cologne: Oktagon.

2001

Chambers, Kristin, and Roxana Marcoci. *Threads of Vision: Toward a New Feminine Poetics*. Cleveland, OH: Cleveland Center for Contemporary Art.

2017

Tuggar, Fatimah. "Methods, Making, and West African Influences in the Work of Fatimah Tuggar." *African Arts* 50, no. 4: 12–17.

2014

Collier, Delinda. "Obsolescing Analog Africa: A Re-Reading of the 'Digital' in Digital Art." *Critical Interventions: Journal of African Art History and Visual Culture* 8: 279–289.

2013

Tuggar, Fatimah. "Montage as a Tool of Political Visual Realignment." *Visual Communication* 12, no. 3: 375–392.

Hamilton, Elizabeth. "Analog Girls in a Digital World: Fatimah Tuggar's Afrofuturist Intervention in the Politics of Traditional African Art." *Journal of Contemporary African Art* 33, no. 13: 71–79.

Green-Simms, Lindsey and Simon Lewis, eds. *African Writing in the Twenty-First Century*, special issue of *Journal of Commonwealth and Postcolonial Studies* 1, no. 1 (Spring).

2008

Rollefson, J. Griffith. "The Robot Voodoo Power: Afrofuturism and Anti-Anti-Essentialism from Sun Ra to Kool Keith." *Black Music Research Journal* 28, no. 1: 83–109.

Vogel, Carol. "Concourse Collages." *The New York Times* (October 17).

Davis, Ben. "The Forbidden City: Street Art, Street Life." *The Village Voice* (September 30).

Cotter, Holland. "Finding Art in the Asphalt." *The New York Times* (September 11).

Powlis, Peter C. "How Street Is It." *Art News* (September).

2006

McKee, Yates. "The Politics of the Plane: On Fatimah Tuggar's Working Woman." *Visual Anthropology* 19, no. 5 (October–December): 417.

2005

Fortin, Sylvie. "Digital Trafficking, Fatimah Tuggar's Imag(in)ing of Contemporary Africa." *Art Papers* (March–April): 24–29.

2004

Fleetwood, Nicole R. "Visible Seams: Gender, Race, Technology, and the Media Art of Fatimah Tuggar." *Signs: Journal of Women in Culture and Society* 30, no. 1 (Autumn): 1429–1452.

Wilkin, Karen. "Perhaps Some of These Artists Should Quit." *The Wall Street Journal* (August 4): D4.

Knott, Marie Luise. "Fatimah Tuggar." *Le Monde Diplomatique*, Deutsche Ausgabe (July): 1–3, 8, 10–11.

2003

Janßen, Angelika. "Die Kunst der Zukunft (Curator's Choice)." Lufthansa Magazin (August): 48–56.

Vuylsteke, Catherine. "De Morderne Stem van Afrika." De Morgan (July 8): 6.

Kwakkenbos, Lars. "Kunts met Africaanse Roots." De Standaard (June 28).

Vuegen, Christine. "Afrika in de Artis-Tieke Maalstroom." Kunstbeeld Magazine (June 22): 15.

2002

Murray, Soraya. "Africaine: Candice Breitz, Wangechi Mutu, Tracey Rose, Fatimah Tuggar." *Nka: Journal of Contemporary African Art* 16, no. 1 (Fall): 88–93.

Alexandra Koroxenidis. "Fusion Cuisine." *Frieze*, no. 70 (October): 102–103.

138 "Fatimah Tuggar." *Jahresring*, no. 49 (January): 149–154.

Nelson, Alondra. "Introduction: Future Texts." *Social Texts* 20, no. 71 (Summer): 1–15.

Tuggar, Fatimah. "Images." *Social Texts* 20, no. 71 (Summer): 17–19.

2001

Hazout-Dreyfus, Laurence. "La Recette de Fatimah Tuggar. Masa: Mix and Match." *Beaux-Arts Magazine*, no. 205 (June).

Kino, Carol. "Fatimah Tuggar at Greene Naftali." *Art in America* 89, no. 9 (September): 155.

Janus, Elizabeth. "Geneva: Fatimah Tuggar: Art and Public." *Artforum International* 39, no. 5 (January 2001): 147.

Barro, David. "Fatimah Tuggar." *Lapiz* 20, no. 177 (November): 71.

2000

Sirmans, Franklin. "Fatimah Tuggar." *Time Out New York* (December 28–January 4): 63.

Johnson, Ken. "Fatimah Tuggar." *The New York Times* (December 22).

Levin. "Voice Choice: Fusion Cuisine." *The Village Voice* (October 24).

Bloch, Ricardo. "Istanbul." *Art Papers* (January/February): 58–59.

1999

Barlet, Oliver. "Art africain et nouvelles technologies." *Africultures*, no. 909: 95–96.

Cotter, Holland. "Lost and Found." *The New York Times* (July 16): E37.

Robert, C.M. "Istanbul and the Biennial Paradigm." *NY Arts* 4, no. 12: 14–15.

Blackburn, "Spaceship Earth." *NY Arts Magazine* 4, no. 3 (March): 41.

Cotter, Holland, "Changes Aside, Soho is Still Very Much Soho." *The New York Times* (February 12).

1998

Becker, Carol and Okwui Enwezor. "The Second Johannesburg Biennale." *Art Journal* 57, no. 2 (Summer): 86–107.

Becker, Carol. "Interview with Okwui Enwezor." *Art Journal* 57, no. 2 (Summer): 87–107.

Tuggar, Fatimah. "Two Views of Contemporary Africa." *The International Review of African American Art* (December): 12.

Lowe, Adam, Rose Arthur, Barbara Einzig, and Bill Jones. "Digital Prints Gallery." *Artbyte* 1, no. 2 (July): 6–15.

Sullivan, Gary. "Reading Tuggar's *Village Spells*" *Plexus.org* (Summer): https://plexus.org/tuggar/sullivan.html

1997

Munitz, Benita. "Go With Me and I Will Go With You." *Cape Times* (October 31).

1996

Cotter, Holland. "Act/Language." *The New York Times* (December 6): C24.

Plagens, Peter. "School is Out, Far Out." *Newsweek* (January 24): 64–65.

AUTHOR BIOGRAPHIES

Amanda Gilvin is the Sonja Novak Koerner '51 Senior Curator of Collections and Assistant Director of Curatorial Affairs at the Davis Museum at Wellesley College. Her past exhibitions include *Life on Paper: Contemporary Prints from South Africa* (Davis Museum at Wellesley College, 2017) and *El Anatsui: New Worlds* (Mount Holyoke College Art Museum, 2014). She writes on textiles, contemporary art, and museums of Africa and the African Diaspora, and her articles have been published in *African Studies Review*, *Critical Interventions*, *African Arts*, and *Nka: Journal of Contemporary African Art*. She was the lead editor of *Collaborative Futures: Critical Perspectives on Publicly Active Graduate Education* (2012). Her forthcoming book, *Mining Beauty: Art and Development in Niger* includes an analysis of the Musée National Boubou Hama du Niger.

Delinda Collier is Associate Professor of Art History, Theory, and Criticism at the School of the Art Institute of Chicago, where she teaches courses on modern and contemporary African art, new media studies, and Cold War modernisms. She is the author of the books *Repainting the Walls of Lunda: Information Colonialism and Angolan Art* (2016) and the forthcoming *Media Primitivism: Technological Art in Africa*. She has published articles and reviews in *Convocarte*, *Nka*, *African Art*, *Third Text*, *Critical Interventions*, *ISEA Electronic Almanac*, and *Times Literary Supplement*.

Nicole R. Fleetwood is a writer, curator, and professor of American Studies and Art History at Rutgers University, New Brunswick. She writes on contemporary art and visual culture, black cultural history, gender and feminist studies, performance, creative nonfiction, and poverty studies. Her books are *Marking Time: Art in the Era of Mass Incarceration* (forthcoming), *On Racial Icons: Blackness and the Public Imagination* (2015), and *Troubling Vision: Performance, Visuality, and Blackness* (2011). Her work has been supported by the ACLS, Cullman Center for Scholars and Writers, Ford Foundation, NJ Council for the Humanities, NEH, Schomburg Center, and Whiting Foundation.

Jennifer Bajorek is Associate Professor of Comparative Literature and Visual Studies at Hampshire College and a Research Associate in the Faculty of Art, Design, and Architecture at the University of Johannesburg. She is the author of *Counterfeit Capital* (Stanford, 2008) and of numerous articles, essays, and exhibition reviews on literature, philosophy, photography, and contemporary art. She has been a research fellow at Cornell University, Rutgers University, and the Clark Art Institute and the recipient of numerous grants to support her writing and research, including a Creative Capital/Arts Writers Grant from the Andy Warhol Foundation. Her latest book, *Unfixed: Photography and Decolonial Imagination in West Africa*, is forthcoming from Duke University Press (2020).

140

ACKNOWLEDGMENTS

The Davis Museum gratefully acknowledges the generous support that made this project possible:

The Andy Warhol Foundation for the Visual Arts

BrickSimple LLC

Wellesley College Friends of Art at the Davis

Kathryn Wasserman Davis '28 Fund for World Cultures and Leadership

Mildred Cooper Glimcher '61 Endowed Fund

E. Franklin Robbins Art Museum Fund

Davis Museum and Cultural Center Endowed Fund

Anonymous '70 Endowed Davis Museum Program Fund

Judith Blough Wentz '57 Museum Programs Fund

Constance Rhind Robey '81 Fund for Museum Exhibitions

The Davis Museum is an intensely collaborative environment, and every staff member contributes to the realization of our projects. Many thanks go to:

Bryan Beckwith, Security Supervisor

Mark Beeman, Manager of Exhibitions and Collections Preparation

Helen Connor, Assistant Registrar for Exhibitions and Digital Resources

Carrie Cushman, Linda Wyatt Gruber '66 Curatorial Fellow in Photography

Arthurina Fears, Manager of Museum Education and Programs

Sarina Khan-Reddy, Media Specialist

Alicia LaTores, Friends of Art Curatorial Assistant

Karen McAdams, Friends of Art Coordinator

Bo Mompho, Collections Manager and Head Registrar

Steve Perkins, Security Manager

Kara Schneiderman, Associate Director of Operations and Collections Management

Craig Uram, Assistant Preparator/Collections Care Specialist

Alyssa Wolfe, Executive Assistant to the Director

Joseph Zucca, Security Supervisor

Additional thanks to:

Mary Agnew and Kristen Levesque for media relations and publicity

Special thanks to the students who contributed research to this project:

Laura Baude (Soriano Fellow '16), Siobhan Finlay '18, Veronica Mora '18, Elana Bridges '20, Yanni Li '20, and Maddy Allan-Rahill '20

142

Many thanks to the Wellesley faculty and staff who participated in the Fall 2018 seminar on art, race, gender, and technology funded by The Andy Warhol Foundation for the Visual Arts:

Ama Baafra Abeberese, Assistant Professor of Economics

David T. Olsen, Associate Professor of Art

Elizabeth Siwo, Mastercard Foundation Scholars Program Coordinator

Erich Hatala Matthes, Assistant Professor of Philosophy

Jordan Tynes, Manager of Scholarly Innovations

Kellie Carter Jackson, Assistant Professor of Africana Studies

Nikki A. Greene, Assistant Professor of Art

Orit Shaer, Class of 1966 Associate Professor of Computer Science

Tracey L. Cameron, Assistant Dean of Intercultural Education

Thanks to the departments at Wellesley College that collaborated on the programming for this exhibition:

Africana Studies, Botanic Gardens, Cinema and Media Studies, Computer Science, Economics, Harambee House, Media Arts and Sciences, Paulson Ecology of Place Initiative, Philosophy, Regeneration Farm, Slater International Center, and the Suzy Newhouse Center for the Humanities

Amanda Gilvin also warmly thanks:

Fatimah Tuggar, Lisa Fischman, Claire Whitner, Meredith Fluke, Mary Ross, Clif Stoltze, Katherine Hughes, Courtney Collins, Jesse Berdinka, Maura Hunter, Colin Zelin, Adam Peled, Zachary Weiner, Samrat Bose, Jane Gilvin, Claire Beckett, Brinda Kumar, Elizabeth Perrill, Samara Pearlstein, Roddy Schrock, Sue Ding, Tegan Bristow, Kim Berman, Charlotte Ashamu, Sandra Obiago, Edith Ekunke, Kadaria Ahmed, Victor Ehikhamenor, Ndidi Dike, Chief Nike Okundaye, Oyindamola Fakeye, Taiye Idahor, Jumoke Sanwo, Dolly Kola-Balogun, Raechell Smith, Nancy Lee Kemper, and David Zielinski

Fatimah Tuggar's acknowledgments:

In grateful remembrance of my friend, sister, and advocate Khadijah Tuggar and my father Abubakar Tuggar, who taught me about humor, courage, adventure, and justice.

Many thanks to:

Abdul Hamidu
Amy Kligman
Abubakar Mohammed
 (Bala Naira)
Baballia Hamisu
Angela E. Rose
Ama Baafra Abeberese
Amanda Gilvin
Aminatu Saleman
André A. Melchor
Adam Peled
Ali Hussani
Barmani Choge
Binta Tuggar
Caleb Putman
Carrie Cushman
Carson Teal

Cary Esser
Clif Stoltze
Colin Zelin
David T. Olsen
Delinda J. Collier
Dan Asabe Uba
Dan Lami
Elana Bridges
Elizabeth Siwo
Erich Hatala Matthes
Hafsat Abubakar
Haruna Baffa
Haruna OG
Ikem Stanley Okoye
Jai Hart
Jamila Hamisu
Jennifer Bajorek
Jesse Berdinka
Jimoh Yusuf
Joey Orr
Jon E. Walker
Jordan Tynes
Julia Cole
Karen E. Maggs
Katherine Hughes
Kellie Jackson
Krista M. Nichols
Laura Blumenberg
Lisa Fischman

Maddy Allan-Rahill
Mallam Mohammed Dabosa
Margaret Perkins-McGuinness
Mark Beeman
Mary Ross
Mason Kilpatrick
Maura Hunter
Michael Lightsmith
Missy Kennedy
Modé Aderinokun
Mohammed Sada Suleman
Mudassir Ali
Nafiu Jita
Nicole R. Fleetwood
Nikki A. Greene
Orit Shaer
Patrick Alexander
Rush Rankin
Sarina Khan-Reddy
Sarkin Karofi Alhaji Audu Uba
Selina ONeal
Sherry Sparks
Tatiana Gómez Gaggero
Tommy Frank
Tracey L. Cameron
Yanni Li
Zachary Weiner

Belger Crane Yard Studios
BrickSimple
Charlotte Street Foundation
Davis Museum at
 Wellesley College
Hirmer Verlag
kNot Theory Media
Kofar Mata Dye Pits
Makoda Village Weaving
 and Textiles
Modé Studios
Stoltze Design Group
Workers at Dangote Kankara
 Cotton Factory
Workers at Funtuwa Textiles

To the many who are unknown to me whose crafts, labor, and found materials have been a resource for my artworks, I am forever grateful.

To those I have worked with in the past on exhibitions and artworks, I appreciate you and your efforts.

143